IMAGES
of America

FALMOUTH

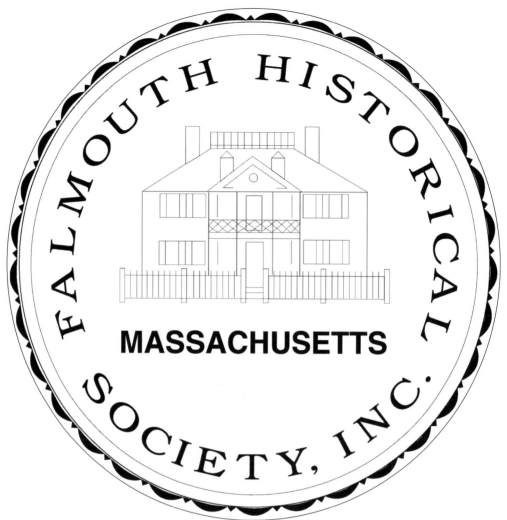

The seal of the Falmouth Historical Society features the Julia Wood House Museum. The society was founded in 1900, and the Julia Wood House became its headquarters in 1932.

IMAGES
of America

FALMOUTH

Ann Sears and Nancy Kougeas
for the Falmouth Historical Society

First published 2002

Published by Arcadia Publishing,
Charleston SC, Chicago IL, Portsmouth NH, San Francisco CA

Printed in Great Britain

Library of Congress Catalog Card Number: 2001096356

For all general information, contact Arcadia Publishing:
Telephone 843-853-2070
Fax 843-853-0044
E-mail sales@arcadiapublishing.com
For customer service and orders:
Toll-free 1-888-313-2665

Visit us on the Internet at www.arcadiapublishing.com

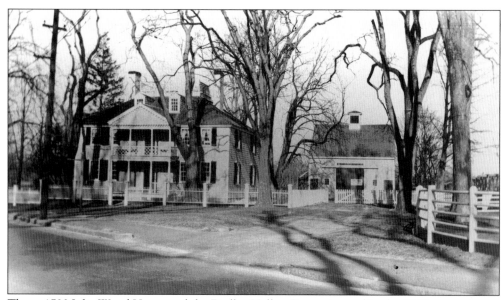

The *c.* 1790 Julia Wood House and the Dudley Hallett Barn, pictured in the 1930s, are museum buildings owned by the Falmouth Historical Society. Located at the foot of the village green, the buildings were given to the society in 1932 by Julia Wood.

CONTENTS

ACKNOWLEDGMENTS

We would like to thank those who so generously lent us photographs to use in this book: Marina Andrews, Marjorie Ballard, Margaret Briana, Philip Choate, Alice Ciambelli, James Cardoza, Douglas Correllus, Bill Dyer, the Falmouth Enterprise, the Falmouth Historical Commission, Falmouth Public Schools, Fleet Bank, Don Fish, Isabelle Hankinson, Pat Lauber, Marine Biological Laboratory Archives, U.S. Marine Fisheries, Colin MacDougall, Mystic Seaport, the National Archives, Flossie Richardson of the Elm Arch Inn, Cynthia Sacht, Kate Sears, the Society for the Preservation of New England Antiquities, Kevin Smith, Spinner Publications, and the Woods Hole Oceanographic Institution. We would also like to express our appreciation to Florence Fitts and Dorothy Svenning for the care they have given photographs at the Falmouth Historical Society and to the late Arnold Dyer for the identification and background notes he attached to many of the photographs we have used. Photographs that do not have credits are from the collection of the Falmouth Historical Society.

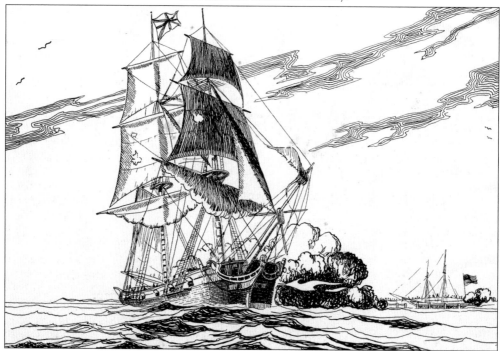

This image of the British ship *Nimrod* shelling Falmouth during the War of 1812 was drawn by Lloyd T. Nightingale in the mid-20th century.

INTRODUCTION

Towns change. Industries come and go, land is plowed under, and buildings are renovated or torn down. Would those who lived in Falmouth 300 years ago recognize the Falmouth of today? We would like to think that if Elijah Swift came back, he would recognize the village green, still the town's centerpiece. We would hope, too, that a summer visitor from the 1890s would recognize Falmouth Heights or the Quissett Harbor House and that Gertrude Stein, once a student at the Marine Biological Laboratory, would still feel at home in Woods Hole.

History is about memory, and one way to preserve memory is to preserve tangible reminders of the past. Buildings, landscapes, photographs, letters, whaling journals, even a teacup or writing implement—all have something to tell us. Since history, as someone once said, is what happened a moment ago, the work of a historical society is multifaceted and never-ending. Luckily for us, Falmouth citizens took an early interest in their past. The Falmouth Historical Society was established in 1900 and began to collect manuscripts and photographs. In 1932, the society acquired the Julia Wood House and, in the 1970s, the Conant House, where its office, archives, and library are located. The Dudley Hallett barn was rebuilt in 2001.

In looking through the society's photographs, we came to appreciate anew how varied and rich the history of Falmouth is. The problem before us was how to choose and arrange the approximately 200 photographs that best show this town of eight villages and many eras. We decided to arrange the book chronologically, rather than by subject or village, to give an idea of what Falmouth looked liked during these different periods. There are no photographs of Falmouth's early history, so we have used paintings, sketches, and modern-day photographs of historic buildings to tell the story. Our chapters are not equal in length because there are no neat dividing times in history, but we have summarized them below.

Jonathan Hatch and Isaac Robinson arrived from Barnstable as the first settlers of Falmouth in 1660. They were unusually tolerant men—Quaker sympathizers at a time when Quakers were persecuted in Massachusetts. Robinson operated an inn before moving on to Martha's Vineyard. Hatch ran a farm. What is today Falmouth's greatest attraction—its spectacular coastline—held little interest for them. The earliest sketch of Falmouth village, by John Warner Barber, gives no hint of Vineyard Sound less than a mile south or of Buzzards Bay two miles west.

Other colonists soon settled in Woods Hole. The first Quakers arrived in West Falmouth in 1673. At about the same time, members of the Nye family began moving from Sandwich to North Falmouth. By 1795, the selectmen's map shows that the town boundaries included East Falmouth and part of Waquoit. Sandy roads isolated Falmouth from other Cape communities that were clustered around Cape Cod Bay to the north. Falmouth residents, therefore, turned to the sea for their connections with the outside world, trading with towns and cities to the south. For many years, Falmouth men wintered in Charleston, South Carolina, working as carpenters and mechanics.

The town's location and dependence on coastal trade made it particularly vulnerable to the

British blockades of the American Revolution and the War of 1812. The Falmouth Militia proved its worth in both wars as it battled British forces to protect the town and its supply lines. After the War of 1812, Elijah Swift rose to prominence. He was a larger-than-life figure during this period, establishing the whaling and live oak lumbering industries to employ townspeople.

In the next major era, Falmouth men and many of their wives traveled the world in their search for whale oil. As maritime industries and commerce died, however, the town looked anxiously to a railroad connection to the rest of the country.

When the railroad finally arrived in 1872, it brought the town new life as a summer resort, and summer tourism has been a mainstay of the economy ever since. The era also saw scientists discovering Woods Hole and the first Portuguese immigrants establishing family farms in East Falmouth and Teaticket.

The new summer residents needed services, and the town responded with graceful architecture in new municipal buildings, including a town hall, a library, and schools. The automobile increased the ease with which visitors could arrive. A new harbor was created to add to the town's attractiveness as a resort center. Large hotels were built.

World War I ended the golden years of summer. Although Falmouth remained at heart a small country town, it began experimenting with modern technology. The town was electrified. School buses transported students, and Main Street was rebuilt. Large-scale farming was attempted. Nurses worked to improve community health.

During World War II, the town was enveloped by the war effort. Hundreds of thousands of soldiers and sailors lived at Camp Edwards to the north and in Woods Hole and Waquoit. The scientific community grew. The taste of year-round employment whetted the town's appetite for more development.

The postwar period saw the emergence of the Woods Hole Oceanographic Institution as a leading part of the town's economy. The family farms of East Falmouth and Teaticket were broken up into subdivisions. Tourism changed, too. Highways made it easier to commute to Boston, and families that once stayed in hotels built their own summer cottages.

Who will write the next chapter of this book? We hope that you will join us at the Falmouth Historical Society and help us in this most interesting task.

—Ann Sears and Nancy Kougeas
for the Falmouth Historical Society

One

SETTLEMENT

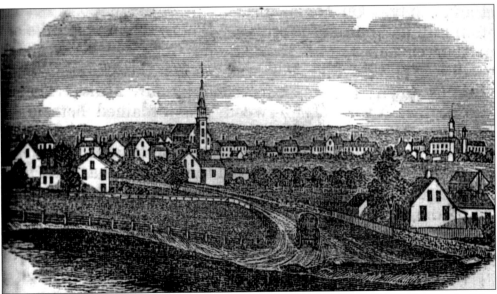

The earliest sketch of Falmouth village appears in the 1839 *History of Massachusetts*, by John Warner Barber. It shows the First Congregational Church standing on the village green and the new private Lawrence Academy, to the far right. The little half Cape on Locust Street in the foreground is now a full Cape. This hillside view of the town gives no hint of Falmouth's important coastline less than a mile away.

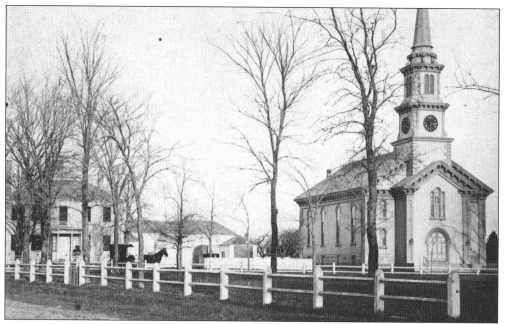

Today's village green took its triangular shape in 1756, when the meetinghouse was moved there from its site near the Old Burying Ground. The meetinghouse served as town hall and town church. The green—where the militia trained and cattle grazed—is now the town's ceremonial center where flags are raised, Christmas trees lit, and protests lodged. Many Colonial and Federal houses remain in place, framing one of New England's quintessential village greens. The green is listed on the National Register of Historic Places.

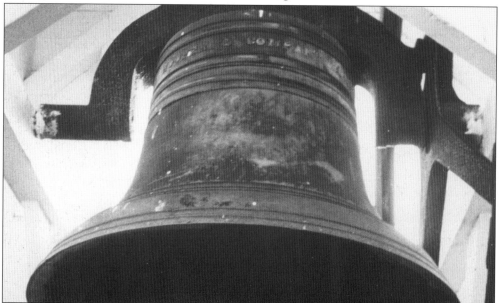

The Paul Revere Bell in the steeple of the First Congregational Church rings on the hour—sometimes a few minutes late. The bell was a gift of Timothy Crocker in 1796, celebrating the third reconstruction of the church. It was the 15th bell cast by Paul Revere and one of 37 still in existence. It is engraved, "The living to the church I call, and to the grave I summon all."

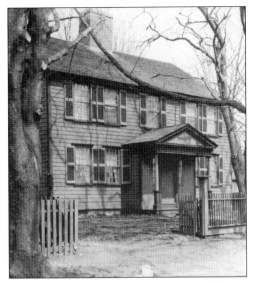

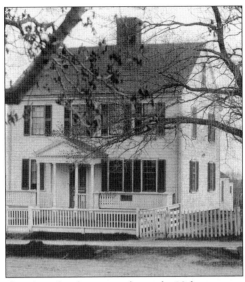

Left: The town's first minister, Samuel Shiverick, lived in this house in the early 18th century. Shiverick lived in precarious circumstances because the town paid his salary irregularly. The house was demolished and replaced by the post office in 1938. The first minister is remembered in the name of nearby Shiverick's Pond. (Courtesy of the Society for the Preservation of New England Antiquities.) *Right:* Capt. John Hatch, a descendant of town founder Jonathan Hatch, built this house *c.* 1750. The original asymmetrical three-quarter shape has been maintained. The building, listed on the National Register of Historic Places, is now the rectory of the St. Barnabas Episcopal parish.

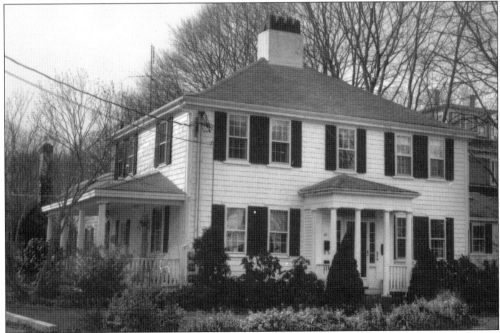

The Consider Hatch house, built *c.* 1767 on the village green, is named for an early town clerk who lived in the house. It is now divided into four condominiums and is listed on the National Register of Historic Places. Large central chimneys help date the three houses shown on this page.

11

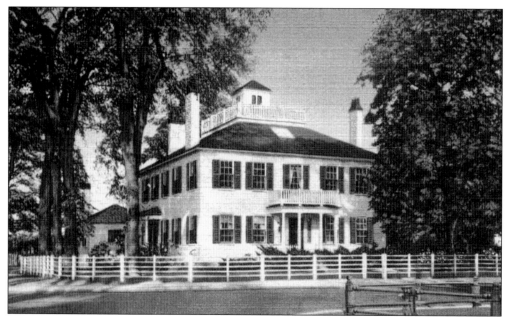

The present-day parsonage of the First Congregational Church was built by Capt. William Bodfish in 1812. In 1816, he interrupted a voyage to Europe to marry Mary Crocker and take her on a hurried honeymoon trip around the green from her house to this home before returning to his waiting ship. The building appears on the National Register of Historic Places.

In 1976, the town reactivated its militia for the national bicentennial. The Falmouth Militia is pictured here in formal dress for a reenactment of the Battle of Falmouth of April 3, 1779. On that date, a fleet of 10 British ships intent on burning down the town was repulsed by the militia dug in on Surf Drive beach. An innkeeper on the Elizabeth Islands had sent advance warning of the attack. (Courtesy of the Falmouth Enterprise.)

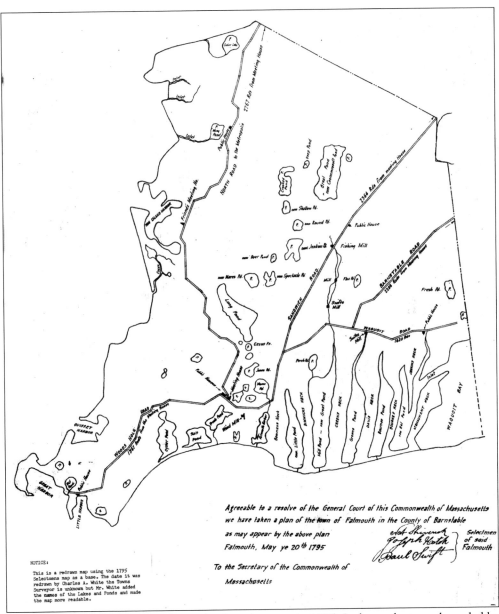

Agreeable to a resolve of the General Court of this Commonwealth of Massachusetts we have taken a plan of the town of Falmouth in the County of Barnstable as may appear by the above plan

Falmouth, May ye 20th 1795

To the Secretary of the Commonwealth of Massachusetts

Selectmen of said Falmouth

The first map of the town was drawn for the selectmen in 1795. It shows the town bounded by Vineyard Sound to the south and Buzzards Bay to the west. Falmouth village is located at the intersection of the road from North Falmouth to Woods Hole and the road east toward Barnstable. Parts of the road system follow old Native American trails north along the hills on the west and east along the present-day Route 28.

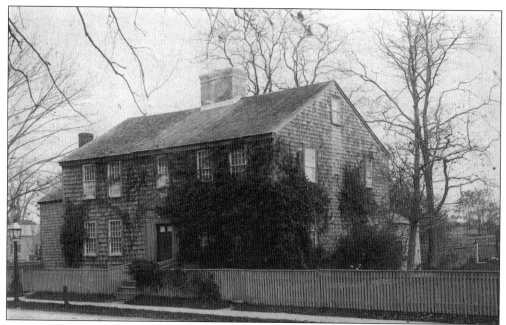

Joseph Palmer, captain of the Falmouth Militia during the Revolution, became the town's first postmaster in 1795. He ran the post office in his home on Palmer Avenue. The house was torn down in the 1920s to make room for the parking lot of the Queen's Buyway, an early shopping center.

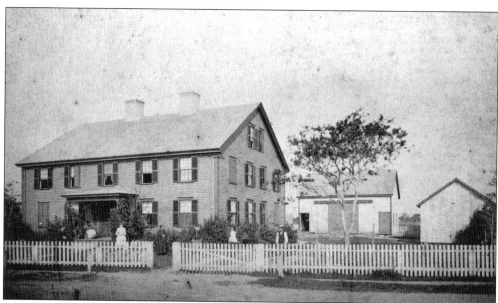

The Falmouth Poor House is one of the few remaining buildings of its kind on Cape Cod. It was established in 1812 in response to a state law requiring towns to care for unfortunate residents. When the state assumed welfare responsibilities in the 1960s, the town allowed the Artists' Guild to use the building for exhibits and workshops. The guild removed the partitions that had separated the eight-by-eight-foot cubicles for inmates. The building is listed on the National Register of Historic Places.

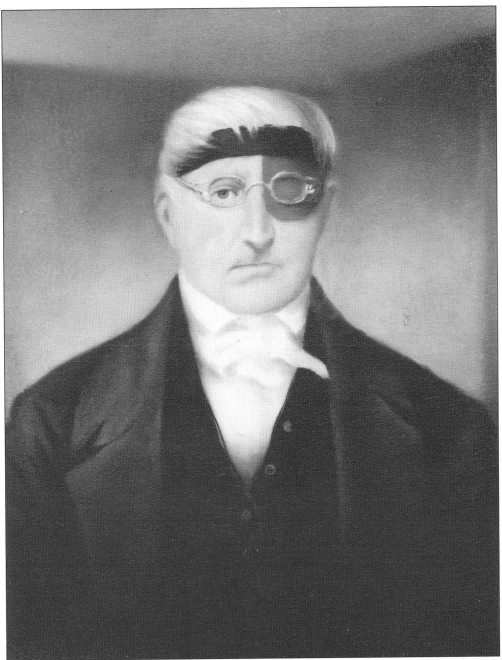

The town's leading businessman, Elijah Swift, was a larger-than-life figure. He began his career as a carpenter, went into the housebuilding business in South Carolina, and in 1816 won the first of a number of federal contracts to supply heavy live oak timber from the South Carolina coast to navy shipbuilders. (The use of live oak in the construction of the USS *Constitution* was responsible for its nickname Old Ironsides.) With the income from the first contract, Swift established the first bank on Cape Cod and took Falmouth into the whaling industry, building and outfitting ships in Woods Hole. He planted elm trees around the village green and provided the first fence, offering to remove them if the town decided it did not want them.

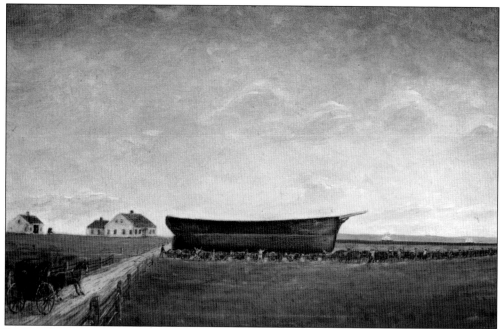

During the War of 1812, Elijah Swift swore that the British would not keep him from his business interests in South Carolina. With the British wrecking havoc on Falmouth shipping, he built the *Status AnteBellum* in his front yard, but at a safe distance from British patrols in Vineyard Sound. Fifty oxen hauled it from what is now the library lawn down Shore Street to be launched. This painting was done by Franklin L. Gifford in the 1920s.

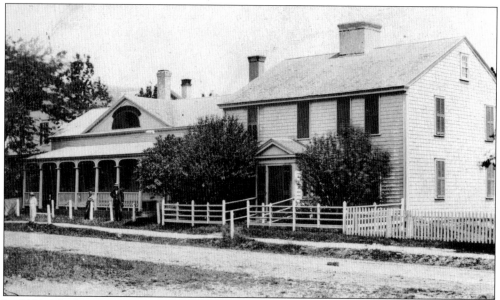

In 1821, Elijah Swift built this first bank on Cape Cod at the edge of the village green. The bank contained a reading room where whaling captains could meet and look over newspapers from New Bedford and Boston. The attached house was provided for the bank's cashier. A new bank replaced the old buildings in 1951. The Falmouth bank was acquired by a larger bank in 1992.

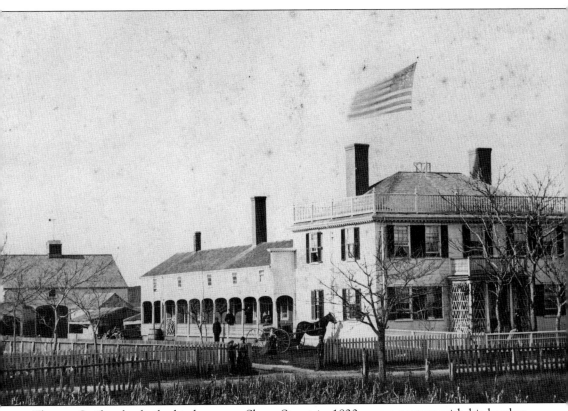

Thomas Swift, who built this house on Shore Street in 1820, was a partner with his brother Elijah Swift in the live oak lumbering business on the South Carolina coast. Boston businessman James Madison Beebe acquired the house in 1872 and became one of the first of many wealthy summer residents to settle in town. He created a 100-acre dairy farm behind the house.

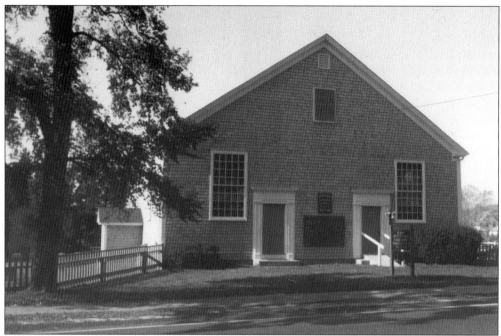

West Falmouth's 1841 Quaker Meeting House replaced two prior structures, the first built in 1725. Followers of the new religion began moving into more tolerant Falmouth in 1673 to avoid persecution in Sandwich for their refusal to pay taxes to support the Congregational church. After almost dying out in the early 20th century, Quakers have experienced a resurgence in membership. The meetinghouse is listed on the National Register of Historic Places.

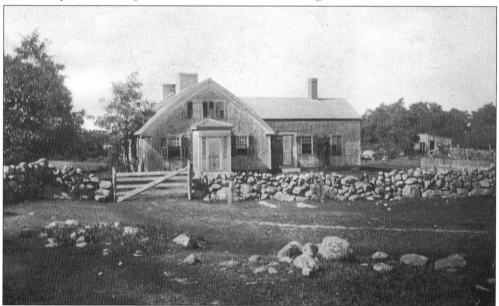

The Bowerman house of West Falmouth may be the oldest in town. Parts of the farmhouse date to before 1700. It has been called the "bowed-roof house" and the "ship's bottom house" because of its unusual roof. The house remained in the Bowerman family for nearly 300 years. In 1967, an owner opened it to the public as a museum. It was sold out of the family in the 1990s.

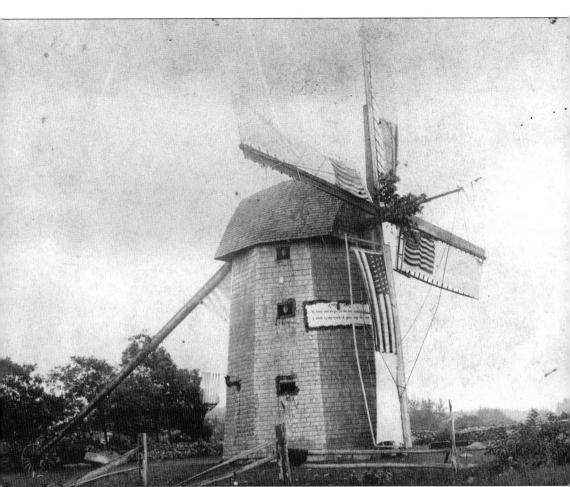

This 1787 windmill was a West Falmouth landmark until 1922, when it was moved to Brockton to serve as the trademark of the Dutchland Farms Ice Cream Company. It burned in 1924. It was originally built so West Falmouth farmers could grind their rye and corn nearby. Its centennial banner in 1887 proclaimed its mission: "Ye come and ye go, ye die and are born. I stick to my work of grinding the corn." (Courtesy of Cynthia Sacht.)

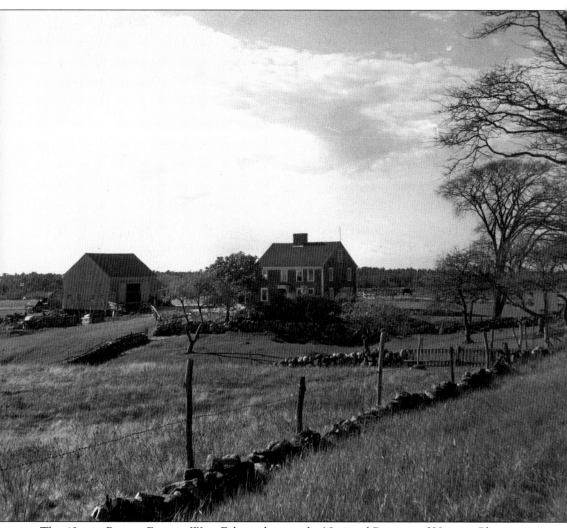

The 40-acre Bourne Farm in West Falmouth is on the National Register of Historic Places as a rare remaining example of an 18th-century Cape Cod farm. The house faces south, away from the road, to receive the greatest exposure to the sun. Over the years, the c. 1775 farm passed from the Crowell family to the Bourne family. The Salt Pond Areas Bird Sanctuaries purchased it in 1980 to protect it from development.

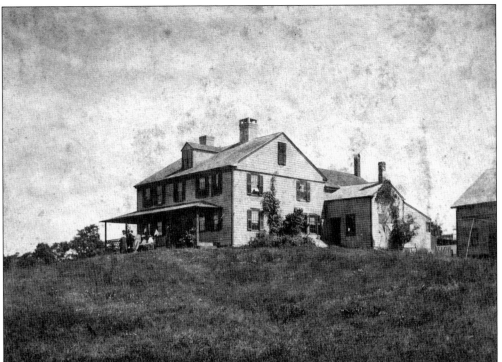

Perched on a hillside overlooking Quissett Harbor, Hurricane Hall was built by Thomas Fish (right) in the 1780s. He was a shipbuilder, a soldier in the Revolution, a sea captain, and a church deacon. The house was called Hurricane Hall because of its unusual exposure to blustery winds. When it was sold out of the family in the 1990s, threats to demolish it led to the creation of the Quissett Historic District.

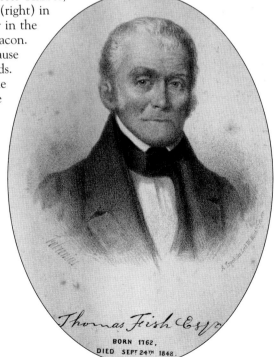

Thomas Fish Esq

BORN 1762,
DIED SEPT 24TH 1848.

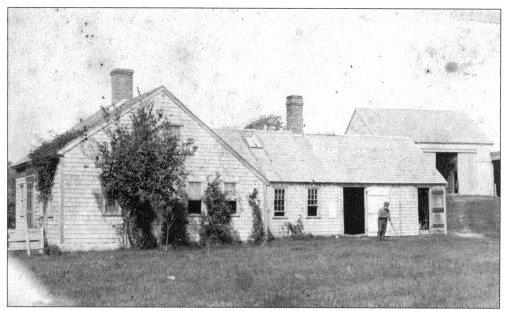

This early Cape Cod farmhouse presided over the Weeks family farm for 200 years before it was demolished in 1938. Purchased by John Weeks of Martha's Vineyard in 1688, the farmlands once extended from Woods Hole Road to Buzzards Bay and were used primarily for grazing sheep. The town purchased the 88-acre Weeks farm for open space in 1998 as an alternative to development. Sheep graze on the land today.

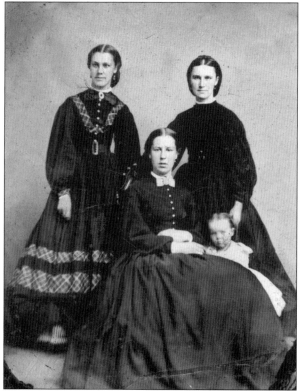

These three sisters grew up on the Weeks farm in the 1880s. In the front is Sarah Edwards with baby Mamie, adopted daughter of Susan Handy. In the back are Lucy Pope Weeks Handy (left) and Susan Handy. (Courtesy of Pat Lauber.)

The Nye Tavern, at 229 Old Main Road in North Falmouth, was a stopping point for stagecoach travelers during most of the 19th century. Among the visitors it hosted was Sen. Daniel Webster, who loved to hunt and fish on Cape Cod. The tavern, dating from *c.* 1775, was one of 24 houses built by members of the Nye family in North Falmouth. Fourteen of them remain. The Nye Tavern is listed on the National Register of Historic Places. (Courtesy of Flossie Richardson.)

The Challenger House, overlooking Little Harbor, has figured prominently in the history of Woods Hole since it was built *c.* 1765 by farmer Ephraim Manassah Swift. From 1820 to 1850, it belonged to shipowner Ward Parker. In 1850, Joseph Story Fay, a Boston merchant and cotton broker, acquired it as a summer residence. In 1948, the Woods Hole Oceanographic Institution opened its administrative offices there.

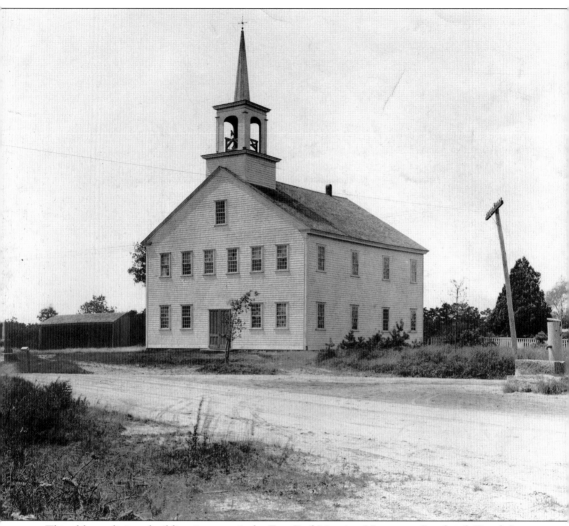

The oldest religious building in town is the East End Meeting House, on Sandwich Road. It was built in 1798 in the style of early Congregational meetinghouses. There was no steeple, and the entrance was on the long side of the building. Falmouth's second Congregational meetinghouse assumed its present appearance in 1841, when Shubael Lawrence offered $10,000 if the congregation would add a steeple and bell and would turn the building so the gable end faced the street. The church was built on the east end of town because growth was anticipated in that area. However, East Falmouth remained rural until the 20th century. When its population grew, the new residents were Portuguese in need of Catholic services. In 1982, the East End Meeting House was given to the growing Falmouth Jewish Congregation.

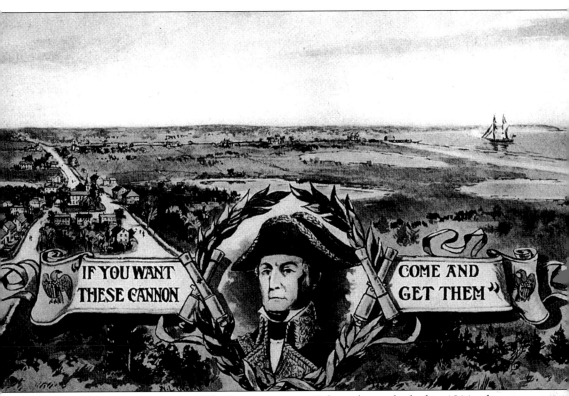

IF YOU WANT THESE CANNON

COME AND GET THEM"

This late-19th-century print by W.L. Greene captures Falmouth as it looked in 1814, when its artillery company refused to surrender its two cannons to the British during the War of 1812. The village green, with the church standing on it, is at left center. Shore Street, the new road from Main Street to the new town dock, is in the background, with open fields running to the right from Main Street to the sea. The British ship *Nimrod* stands off the coast. Pictured at the center is the fiery captain of the artillery company, Weston Jenkins, who refused to surrender the cannon, saying, "If you want these cannon, come and get them." The *Nimrod* bombarded the town for four hours on January 28, 1814, concentrating firepower on Shore Street. Several houses proudly bear the scars of the bombardment. No one was killed. Few were injured. The townspeople were given time to evacuate.

This is a rare 1900 view of the Benjamin Gifford house when it faced Shore Street, before it was moved back and turned to face the water. The cannonball damage in the attic is said to date to the Revolution, not the War of 1812. The Old Stone Dock in the foreground was Falmouth village's primary connection to the outside world from 1817 until the railroad arrived in 1872. The dock replaced an 1806 wooden dock that washed away in an 1815 storm.

A cannonball hole still shows in the men's room of the Nimrod Restaurant on Dillingham Avenue. The restaurant is made up of two 18th-century houses that originally stood on Main Street. The cannonball damage occurred in the smaller Issac Bourne house when the *Nimrod* fired on the town in 1814. The houses became a restaurant in 1955. (Courtesy of Flossie Richardson.)

John Crocker, a master mariner in the Northwest Coast fur trade, built this house on Shore Street in 1806. During the War of 1812, he registered his ship *Harmony* as a privateer under a letter of marque from the U.S. government. His house was one of the hardest hit during the 1814 *Nimrod* bombardment. The house is now part of the Shoreway Acres hotel complex.

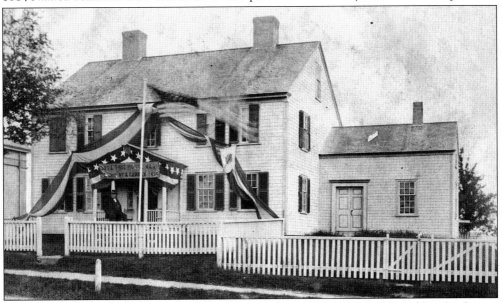

The Elm Arch Inn, another house that proudly displays the scars of the *Nimrod* bombardment, proclaimed its history during the town's bicentennial in 1886. "Struck by Cannonball," says the sign. The house was built in 1811 for Capt. Silas Jones, who was in the China trade. In 1926, it became an inn when it was moved back to make room for more commercial development on Main Street.

The USS *Falmouth* was built at the Charlestown naval shipyard in 1827 with live oak timbers supplied by Elijah Swift of Falmouth. The ship was named for both Falmouth, Massachusetts, and Falmouth, Maine, according to the Massachusetts Historical Society. Both towns suffered from British attacks during the Revolution. This painting was done by John Schmidt. (Courtesy of Fleet Bank, East Main Street, Falmouth.)

Two

THE TURN
TO THE SEA

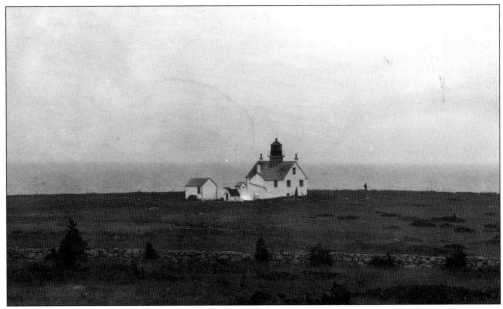

The original Nobska Lighthouse stood on top of the keeper's house. It was built in 1829 to aid the growing traffic in Vineyard Sound. More than 10,000 vessels were estimated to have passed through the sound that year. In 1876, the lighthouse was replaced with a 35-foot steel tower with a light visible 13 miles away and a separate house for the keeper. The current lighthouse is listed on the National Register of Historic Places.

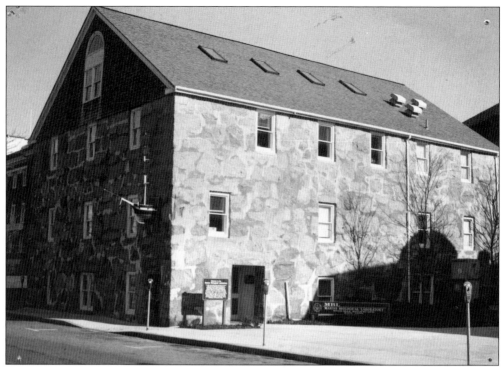

The stone Candle House in Woods Hole is the sole survivor of the town's whaling era. Elijah Swift built it in 1836 to make candles from whale oil. A huge wheel under the roof moved vats and lifted barrels. The building stands opposite the Bar Neck Wharf, which Swift constructed in 1828 to service his whaling fleet. Today, the Candle House holds the offices of the Marine Biological Laboratory. The Woods Hole Oceanographic Institution uses the Bar Neck Wharf. (Courtesy of the Falmouth Enterprise.)

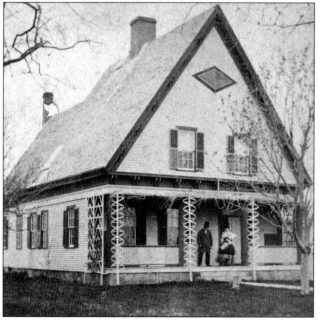

Whaling captain Henry Bunker retired from the sea to this *c.* 1850 Gothic Revival house on Palmer Avenue. The house was unusually modern for Falmouth village but typical of new construction at the time. In 1918, the house was completely remodeled and given a hip roof. After 1969, the Elks organization added to the front and sides so that only the appearance of the second floor indicates the building was once a house.

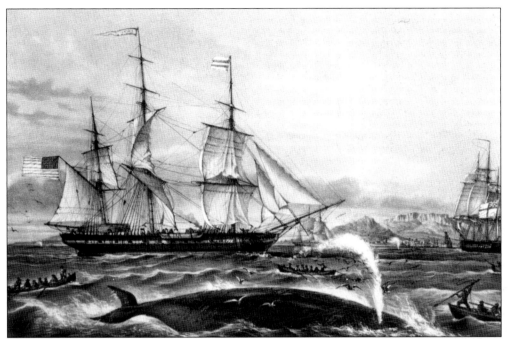

The whale ship *Uncas* was built in Woods Hole for Elijah Swift in 1828. Some of the live oak timbers that his crews harvested in the South were used in its construction. The *Uncas* was one of a dozen Falmouth whale ships that worked out of Woods Hole from 1828 to 1870. The ship is portrayed here in a historic LeBreton print that was used on a Panamanian postage stamp in 1968. (Photography by Kate Sears.)

Capt. Ephraim Eldredge was one of 65 Falmouth men who became whaling captains during the 19th century. Eldredge commanded the *Uncas* and later the *Awashonks*, another Swift whaler. Most of the town's whaling captains took charge of ships based in New Bedford. (Photography by Kate Sears.)

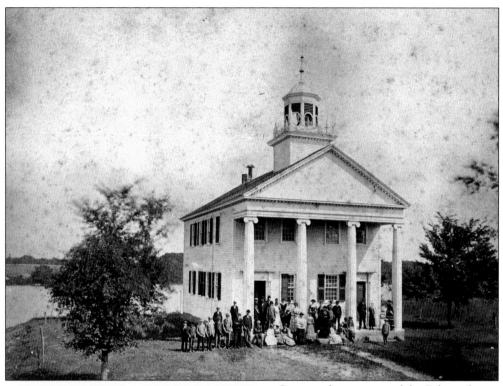

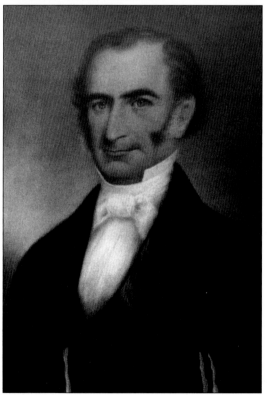

Prior to the opening of the Falmouth Academy in 1834, students had to board in other towns to continue education beyond grammar school. John Jenkins (left), school building committee chairman, had attended the academy in Sandwich. The Falmouth Academy was renamed the Lawrence Academy in 1841 to accept a $10,000 legacy from Shubael Lawrence. In 1890, the town took over the school. It continued the Lawrence name on a new high school in 1895. Today, the junior high school retains the Lawrence name. The original academy served as Legion Hall and is now headquarters for the chamber of commerce. The building is on the National Register of Historic Places.

Two Lawrence Academy instructors prepare for an anatomy class in 1862. The school's most famous student was Helen Hunt Jackson, author of *Ramona*, a romanticized story about the plight of Native Americans in the west. Jackson attended the school from 1844 to 1846 while living with her uncle, Rev. Henry Hooker.

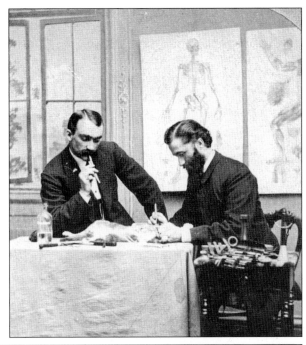

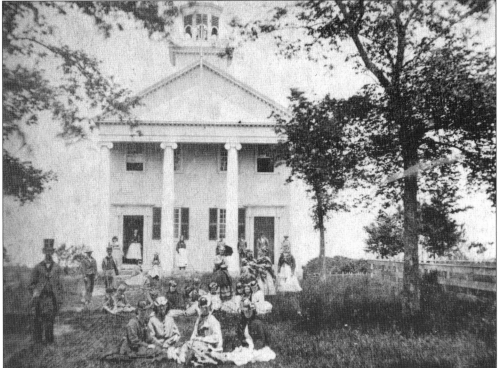

Prof. Lucien Hunt, in top hat and jodhpurs, was the principal of the Lawrence School in 1867. By then, enrollment had dropped from the high in 1845 of 94 students, evenly divided between boys and girls. Several students came from New Bedford, Martha's Vineyard, Sandwich, and Barnstable. One was from Beaufort, South Carolina, and one from Canaan, New York.

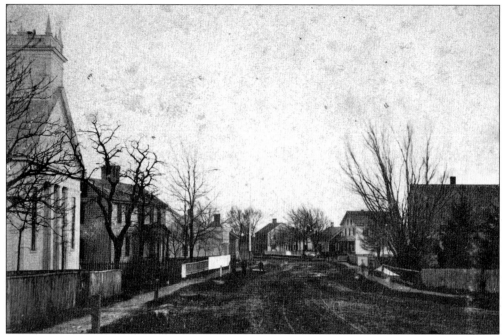

Falmouth's first town hall was the white building on the left in this Main Street view, looking east. It was built in 1840 to comply with the U.S. Constitutional requirements of separation of church and state. Prior to that date, town business had been transacted at the First Congregational Church. When the second town hall was built in 1880, the first was moved to Depot Avenue and converted to apartments.

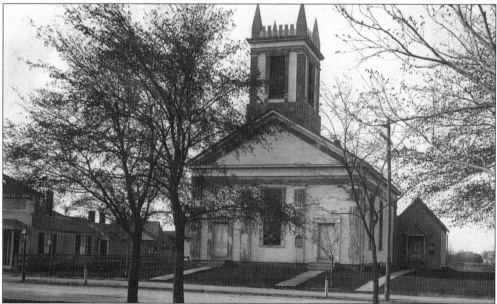

The Methodist church was a fixture on Main Street from 1848 until it was demolished in 1957. Methodist churches were also built in West Falmouth, Woods Hole, and East Falmouth. The Woods Hole church is now the museum for the Woods Hole Oceanographic Institution. Newer churches have been built in Falmouth and West Falmouth.

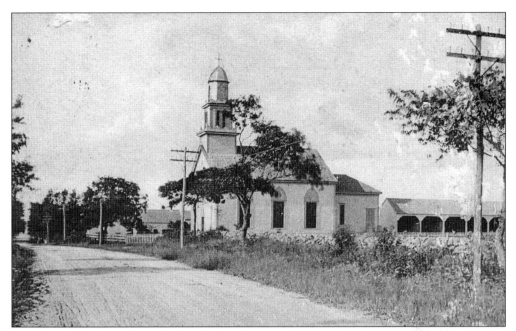

The North Falmouth Congregational Church was built in 1832 as Falmouth's growing villages began to insist on having their own churches nearby. The carriage houses to the right no longer exist. The church is listed on the National Register of Historic Places.

Construction of the Waquoit Congregational Church in 1848 heralded the emergence of Waquoit, once Falmouth's most isolated village, as a self-sufficient community with farms, mills on the Moonakis River, and maritime industries on Waquoit Bay and the Child's River. (Courtesy of Margaret Briana.)

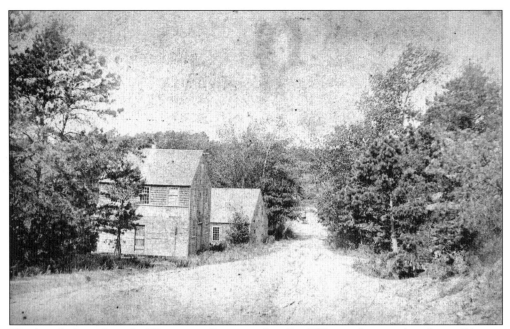

Woolen cloth made in the Waquoit mills was used in Civil War uniforms and in the twill kersey trousers worn by whalers. These Waquoit mill buildings stood on the section of Main Street near the Moonakis River that is now Martin Road. Parts of Waquoit's main road were bypassed when Route 28 was straightened in the mid-20th century. (Courtesy of Margaret Briana.)

Falmouth sent 81 of its men to serve in the Civil War. Capt. Andrew Shiverick was one of 16 who died of wounds or disease. Because many Falmouth men were at sea on lengthy whaling cruises during the war, the town of 2,650 had to recruit additional soldiers from out of town. Irish and black men from other locales—many who never saw Falmouth—helped to fill the town's quota. Two members of the black 54th Regiment (made famous in the movie *Glory*) were listed as Falmouth residents, although they were actually from Indiana. The whale ships of at least two of Falmouth's captains were captured and burned by Confederate commerce raiders during the war. The captains and crews were put to sea in whaleboats and survived.

The first West Falmouth Methodist Church was built in 1857 with an elaborate Italianate steeple. Construction of the church in this traditionally Quaker area came at a time when the Quakers had turned inward and had begun excluding members for infractions of the rules. In 1900, when the stylish new Shingle-style Methodist church was built, the steeple and round-arched windows were removed from the old church and it was converted to an apartment house. (Courtesy of the West Falmouth Library.)

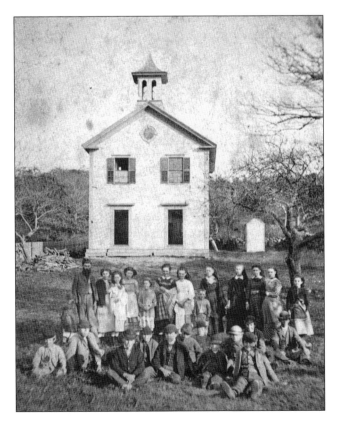

The West Falmouth School and its students are captured forever in an 1860s stereopticon. The double entrances and cupola were removed when the building was moved to 19 Old Dock Road and converted to a residence.

In her autobiography, Katharine Lee Bates, author of the poem "America the Beautiful," described herself as "a shy, near-sighted child always hiding away in a book. It was in vain that unclothed dolls were given her to beguile her into sewing. She would promptly spin a romance that left them wrecked on a desert isle and obliged to wrap themselves in raiment of oak leaves secured by thorns and grasses."

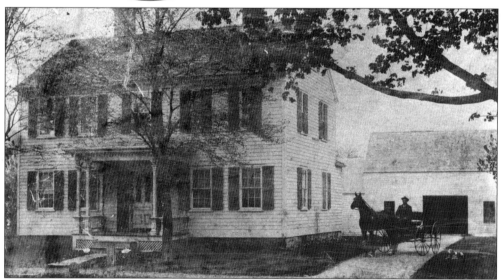

Katharine Lee Bates was born in this house in 1859, the daughter of the minister of the First Congregational Church. Her father died shortly after her birth, leaving the family in dire financial straits. Although the family moved from Falmouth when Katharine was 12, she always remembered the town fondly as "a friendly little village that practiced a neighborly socialism without having heard the term." When she was in her sixties, she included "When Lincoln Died" in her *America the Beautiful* collection. It describes Falmouth as she remembered it as a five-year-old when the little whaling village learned of Lincoln's assassination.

When Lincoln Died

Katharine Lee Bates

A Five-year-old in a Cape Cod village,
 Twenty miles from the rail,
Falmouth, Falmouth, loveliest Falmouth,
Wearing her silvery, pearl embroidered
 Ocean mist for veil;

Her sweet God's Acre a winsome garden
 Whither often would weepers bear
Their gifts of flowers, dear dooryard flowers,
To pale stones carved with a ship or anchor,
 Though no mound was molded there;

For many a Falmouth man lay dreaming
 Under seas of dazzling blue
Mid the rosewhite coral, the rosepink coral,
And some in the Arctic ice were shrouded,
 And the tomb of some none knew.

A five-year-old on the side porch holding
 A fold of her mother's dress,
Mother, Mother, our fair young Mother,
Shaking the breakfast cloth with a flourish
 Of her own gay gallantness.

And across the yard, in her narrow doorway,
 The neighbor I held in dread,
Venomous neighbor, witch of a neighbor,
Lean and gray, with a furtive pussy
 That the boys called Copperhead.

Yet I loved her grandson, a pigmy urchin
 With black eyes glittering sly,
Impish playmate, my earliest playmate,
Whose quick red mouth would snap at and swallow
 The bewildered buzz of a fly.

She shrilled across: "They've shot Abe Lincoln.
 He's dead and I'm glad he's dead."
Lincoln! Lincoln! Abraham Lincoln!
She stood and laughed, that terrible woman,
 And never a word God said.

Back into the kitchen my mother staggered,
 Her face all strange and blanched,
Her deep eyes filling, filling and brimming
With tears that the tablecloth, kept so sacred
 From childish weeping, stanched.

"I will not believe it, I'll not believe it,"
 She sobbed till with drooping head
An old sea-captain, a whaler captain,
Off the stage-coach swung with a Boston paper
 That from house to house he read.

I heard it and hid me under the lilacs
 This mystery to prod.
Lincoln! Lincoln! Abraham Lincoln!
And not one angel to catch the bullet!
 What had become of God?

A robin beyond me hopped and chirruped
 Where the April grasses blew,
As if Lincoln, Lincoln, Abraham Lincoln
Were no more than the worm he tugged at and swallowed.
 I lamented that long worm, too.

Then our lonely village among the sand dunes
 With only its one scant store,
Yet part of a nation, a stricken nation,
Took thought how to honor our saint, our martyr,
 Our hero forevermore.

Wonted to grief, the women of Falmouth
 Hung the old church, pulpit and walls,
With a simple mourning, a sacred mourning,
Already steeped in uttermost anguish,
 Hung it with widow's shawls.

The flag on the village green half-masted,
 Bell tolling upon the air
Lincoln, Lincoln, Abraham Lincoln,
The nation's sorrow I felt my sorrow,
 For my mother's shawl was there.

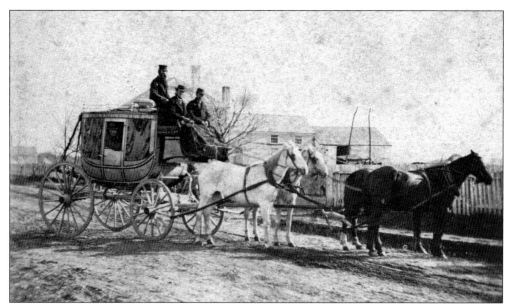

William Hewins's stagecoach played an increasingly important role in Falmouth when rail became the major form of transportation in America. Rail from Boston reached Bourne in 1848 and stopped. Falmouth-bound passengers switched to the stage for the last 20 miles. The mail came by stage. News, including word of Pres. Abraham Lincoln's death, came by stage, as recounted in a Katharine Lee Bates poem. Falmouth leaders feared the town would die without a rail connection. Once the train arrived in 1872, the stagecoach was no longer needed.

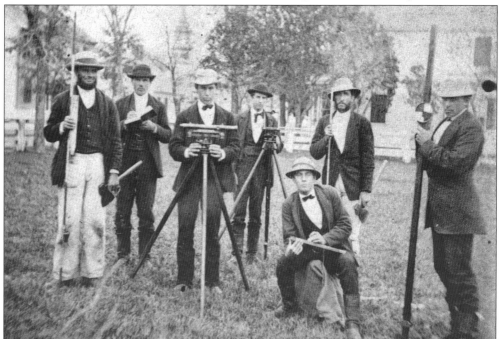

A crew surveying for the railroad signals that the pace of life would soon become faster in Falmouth. When the train came to town in 1872, summer visitors would pour in. A golden era was about to begin.

Three

THE TRAIN BRINGS
GOLDEN SUMMER DAYS

Train service to Falmouth began on July 18, 1872, and Falmouth was forever changed. Almost immediately, the town's 75 miles of coastline that had held little of interest for townspeople were subject to land speculation and development. New summer resort communities grew along the shore—Quissett, Falmouth Heights, Megansett, Menauhant, Chapoquoit, and Penzance—and biological scientists began visiting Woods Hole. Townspeople turned their homes into inns and hotels for summer visitors from Boston and New York. Summer visitors soon became summer residents.

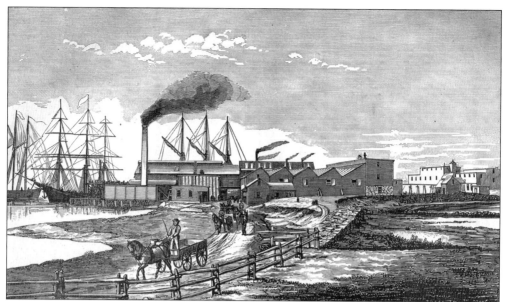

Ironically, the trains came to serve the Pacific Guano Works, which began making fertilizer in Woods Hole in 1863. The plant mixed fish, sulphur, and guano from a Pacific island and needed to transport it to market. Most of its 150 workers were Irish immigrants. When it closed in 1889, Horace Crowell purchased the site and created Penzance Point, one of the wealthiest summer areas in town. (Courtesy of U.S. Marine Fisheries.)

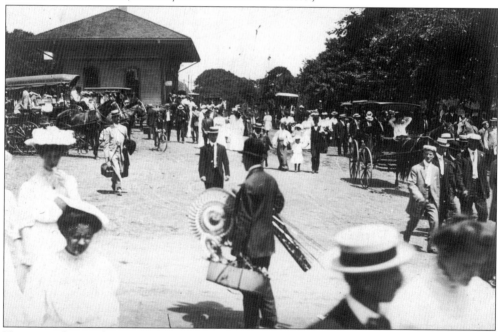

Visitors strike out from the Depot Avenue station in Falmouth to walk to their destinations while others take horse-drawn carriages. The first station, a wooden structure, was replaced with the present brick building in 1913. The Dude train—nicknamed the Flying Dude because of its speed—began in 1884. It was a subscription-only train used by wealthy summer residents. Rail service ended in 1963.

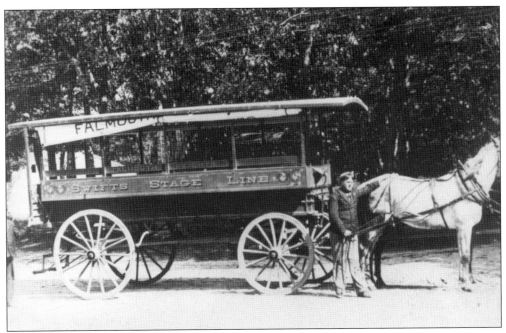

Swift's Stage Line could be hired to take passengers to their hotels.

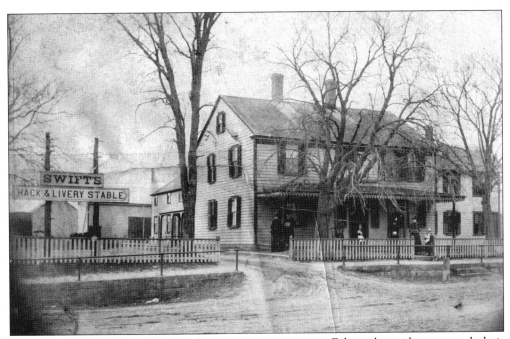

To accommodate the explosion of summer visitors, some Falmouth residents turned their homes into inns. Succanessett House was owned by one of Elijah Swift's sons and was one of the first homes to take in boarders. The Swifts adapted themselves to the changing times, running not only an inn but also a hack and livery service. This house was moved in 1890 to Cahoon Court to make room for the St. Barnabas Church.

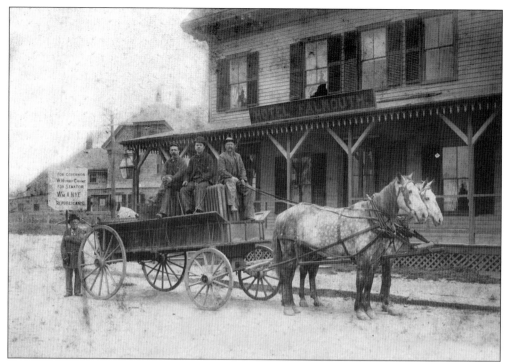

The Hotel Falmouth on the corner of Main and Shore Streets started out as a store *c.* 1843. By 1850, John and Knowles Butler were operating the store. In 1872, it was remodeled and opened as Baker's Hotel. Eight years later, it became the Hotel Falmouth. The campaign sign held by the man at left says, "For Governor W. Murray Crane, For Senator Wm A. Nye, Republicans."

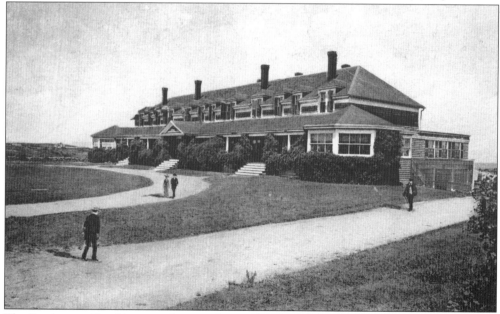

The Breakwater Hotel began as housing for employees of the Pacific Guano Works. When the company failed, the building was remodeled into an elegant hotel for summer visitors. (Courtesy of Marjorie Ballard.)

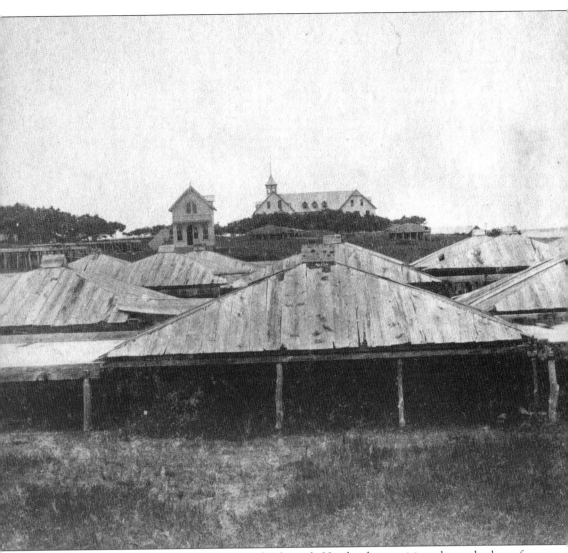

The planned summer cottage community of Falmouth Heights began rising above the last of the old saltworks in 1871. The saltworks sheds in the foreground were the remnant of an industry that lined the shores of Falmouth for more than 50 years when the town was a leading salt producer on Cape Cod. In 1831, Falmouth had 139 works evaporating seawater to make salt. The production of salt, then so necessary to the preservation of meat and fish, was born in the American Revolution as a response to British blockades. The industry died as the duty on imported salt was lowered in the 1840s.

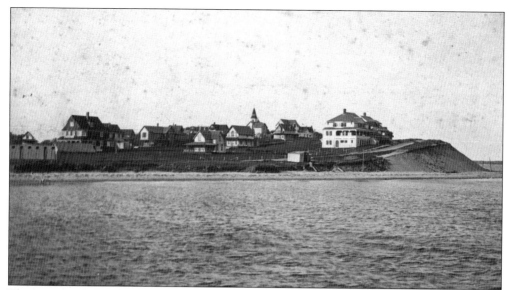

This stretch of Grand Avenue looks very much today as it did in the late 19th century after it was developed by a group of Worcester residents incorporated as the Falmouth Heights Land and Wharf Company. The company planned a 600-house summer community of Falmouth Heights on 100 acres of land. The bathing houses to the far left, which were owned by the Tower House Hotel, were destroyed in the Hurricane of 1938. The tower in the back is the peak of the Observatory.

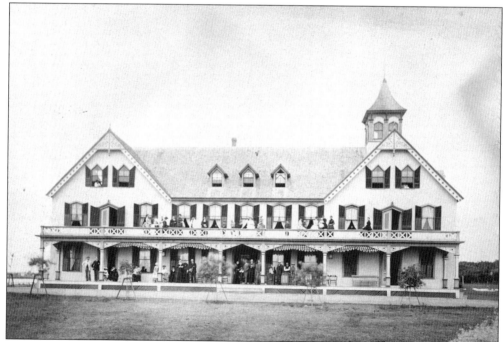

The Tower House Hotel was the first building in Falmouth Heights, opening in 1872. George Tower ran it for almost 30 years. The hotel was taken over by the federal government in World War II to provide housing for officers with the Engineers Amphibian Command. It was demolished in 1960. Mariner's Point, a time-share complex, now stands in its location.

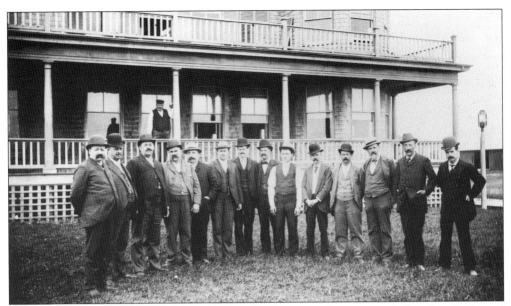

These men are standing outside the Pickwick House on the corner of Grand and Central Avenues. George L. Giddings bought it *c.* 1900 and renamed it the Vineyard Sound House. Today it is remembered as the Park Beach Hotel, which it became in 1943 when purchased by John Peterson, owner of the Cape Codder Hotel. He modernized it by tearing down most of the structure. It has recently been remodeled into a time-share complex.

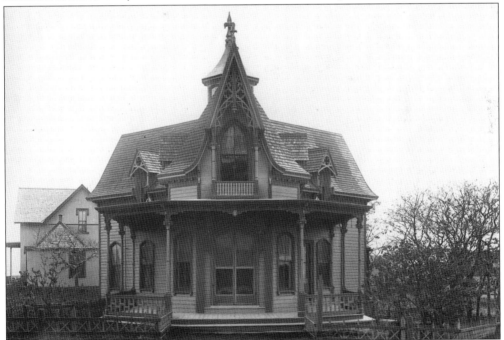

This is the only residence that Falmouth Heights architect Elbridge Boyden of Worcester is known to have designed. The cottage was constructed as a model home to attract buyers to the Heights. Most early homeowners built in a simpler Carpenter Gothic style. The Boyden cottage stands today at the top Crown Circle.

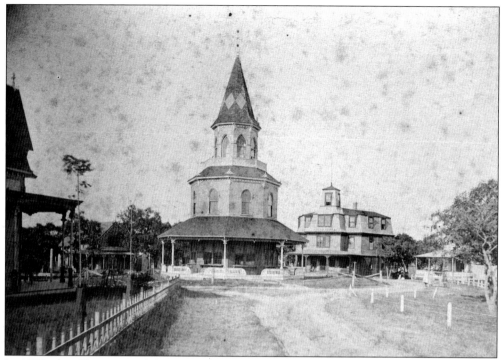

In 1872, the Observatory (above) became the second building constructed by the Land and Wharf Company. It became an interdenominational chapel, the Falmouth Heights Union, in 1891. It was demolished in 1929 (below).

All happy families are alike—at least when they are enjoying their summer homes in Falmouth Heights. Above, an unidentified family assembles on the steps of their cottage. The Carpenter Gothic style of the house indicates that it was one of the earliest built in the new development. Below, George H. Clark, his family, dogs, and several neighbors pose on the porch of his cottage on Lookout Avenue one fine summer day.

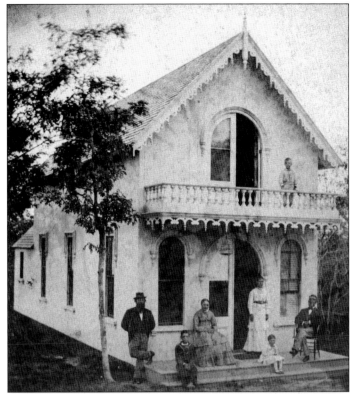

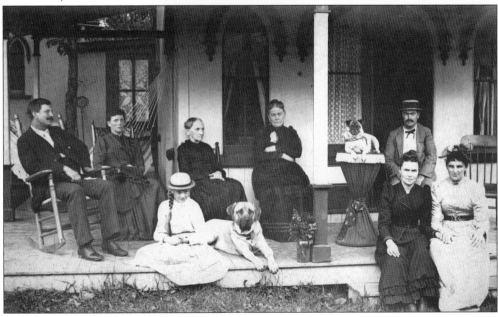

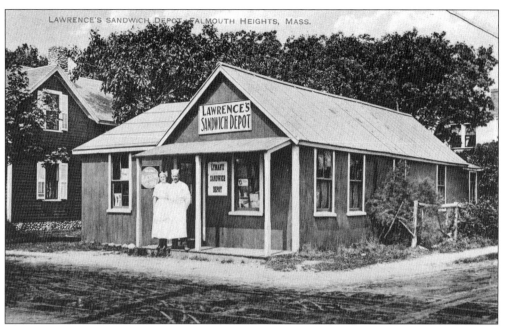

Lawrence's Restaurant started out as a simple sandwich shop where sandwiches were prepared quickly and memorably—without being touched by human hands. Bread was speared onto paper plates with a knife, and fillings were spread with a spatula. The sandwiches were covered, cut in half, and delivered the same way.

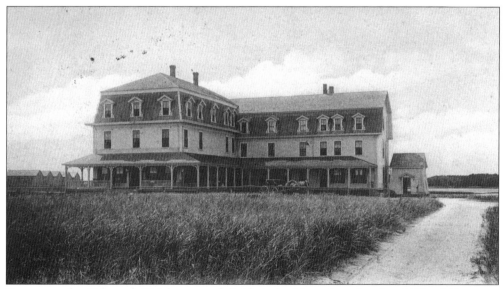

Two years after Falmouth Heights was subdivided, the Menauhant Land and Wharf Company was formed by six Attleboro jewelers and John Tobey of East Falmouth, who saw the potential for a summer resort between Bourne's and Eel Ponds. They built a hotel and a 120-foot-long wharf in 1875. Although remote from downtown Falmouth, the summer community thrived.

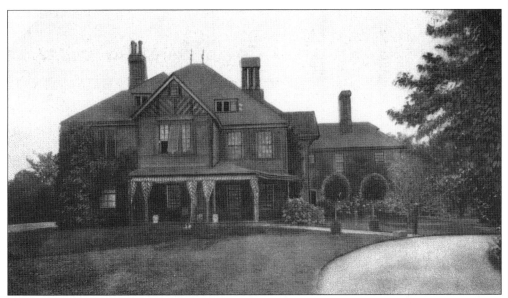

Highfield (above) and Tanglewood (below) were the Beebe family summer estates. When wealthy Boston merchant James Madison Beebe retired, he purchased 600 acres of land on the hill above the railroad station. His children built two grand homes in the English Manor style. Highfield Hall, built in 1878 by F.H. and E.P. Beebe, is now being restored to its former grandeur by a nonprofit group called Historic Highfield. Tanglewood, built by J.A. Beebe, was demolished in 1974.

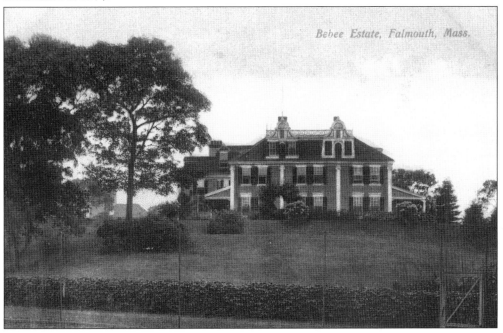

The haughty Franklin Beebe inherited Highfield after the death of his father and older brother Pierson. While most people summered in Falmouth because of its proximity to the sea, the Beebes loved Highfield's woods.

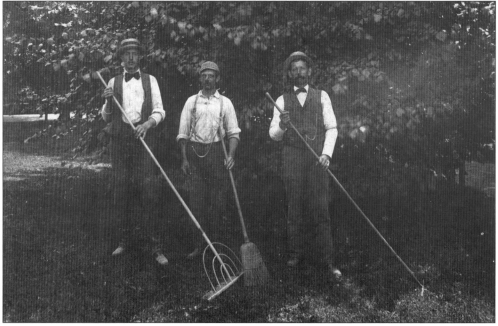

A full complement of servants was required to run a house the size of Highfield Hall. The men here are gardeners. The cover of this book shows four of the Beebe house servants at the town beach on their day off.

The Beebe sons and daughters built the St. Barnabas Church in memory of their parents in 1890. They moved the home of erstwhile town leader Elijah Swift in order to place the church at the tip of the village green. Henry Vaughan was church architect. Wheelwright and Haven of Boston designed the parish house, and the landscape was by Frederick Law Olmsted. The church began as a summer parish primarily for members of the Beebe family.

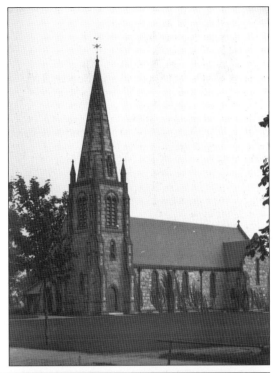

In this 1894 photograph, three elderly gentlemen have pulled up chairs to supervise construction of the stone wall between the St. Barnabas Church and the house next door. Seated on the left is former town clerk William Nye, aged 95. He had moved west to Chicago but returned to pass the summer in Falmouth. (Courtesy of Frank Nickerson.)

The Quissett Harbor House, in the distance, was created in the 1870s by joining two older houses with an addition. Spartan accommodations were the hallmark. The hotel had no running water and only four toilets, but its visitors loved the experience. Many returned each year, some to build large estates along the shore. Cornelia Carey, who ran the hotel before it closed in 1975, left the parkland near the house, including the Knob, to the Salt Pond Areas Bird Sanctuaries.

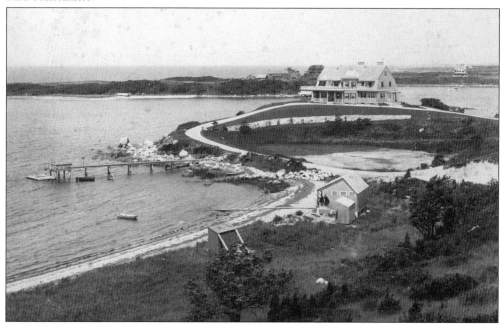

Photographer Baldwin Coolidge captured the Shingle-style Marshall house in Quissett. When larger summer "cottages" became the fashion, New York stockbroker James G. Marshall moved this house inland and built a much larger one. The larger building is now the summer home of the National Academy of Sciences. The smaller house in the photograph remains in the family.

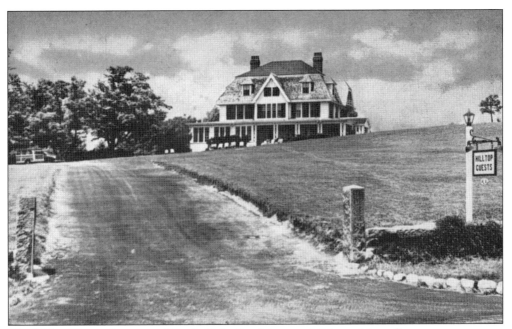

The Helen Turner house on Woods Hole Road is one of Falmouth's earliest summer estates. Built in 1875 on a hill that overlooks Buzzards Bay on one side and Vineyard Sound on the other, the house was remodeled by Charles Whittemore in 1908. It was redesigned again in 2000 to become the headquarters of the Woods Hole Research Center.

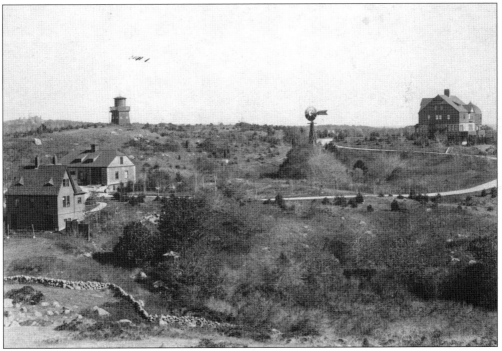

The landscape around Cumloden on the south side of Woods Hole Road is totally different today. Built on sheep grazing land in 1885, Cumloden (right) is now hidden by trees. The house was designed in the Shingle style by artist Frank Hill Smith, a relative of Joseph S. Fay.

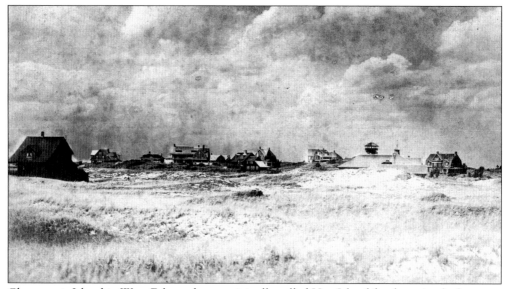

Chapoquoit Island in West Falmouth was originally called Hog Island for the animals that were kept there. Around 1890, sailing enthusiasts recognized the island's potential for development. They convinced the town to build a bridge, thus making the island more accessible. Development of large houses by prosperous summer residents quickly followed.

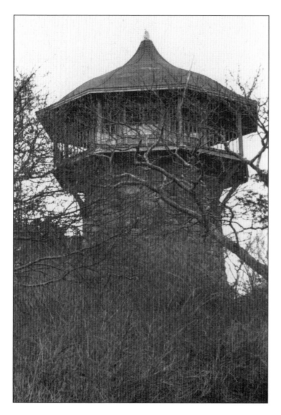

A water tower on the highest point of the island serves as the symbol of Chapoquoit. A spiral wooden staircase wound outside the tower to an observation platform. (Courtesy of the Falmouth Enterprise.)

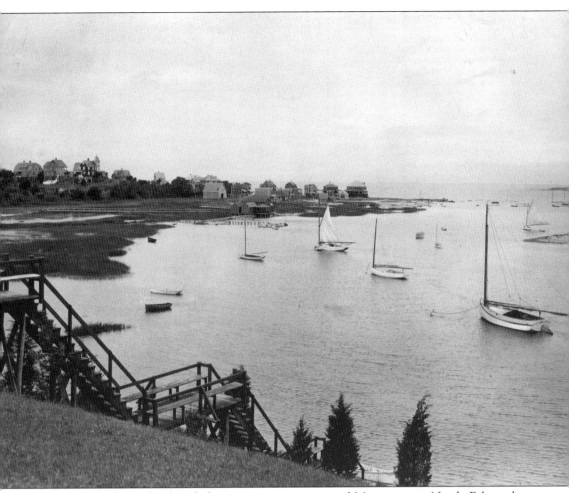

Watertown residents developed the summer community of Megansett in North Falmouth. During the first summer of the fledgling corporation's existence, all members planned to live together in one beach house. The community, however, quickly grew as lots were sold for $5 an acre. (Courtesy of the Society for the Preservation of New England Antiquities.)

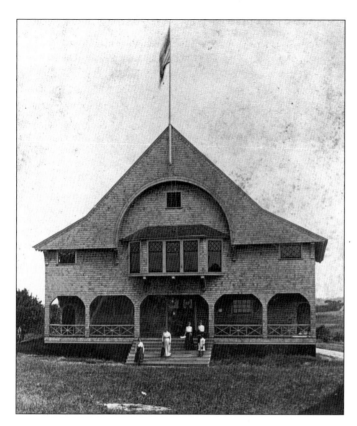

The Megansett Casino was built in 1901 as a recreation and social center for the summer community. It became a movie house and then the first Catholic church in the village. Ownership is now divided into condominiums.

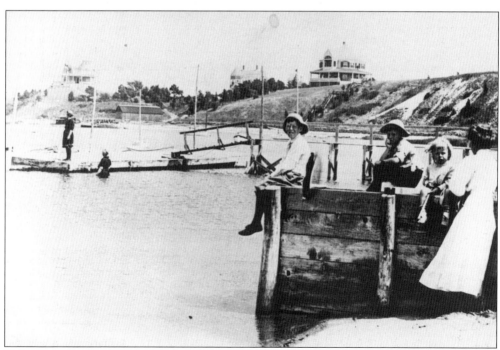

Kids sit on the dock in front of the Megansett ridge.

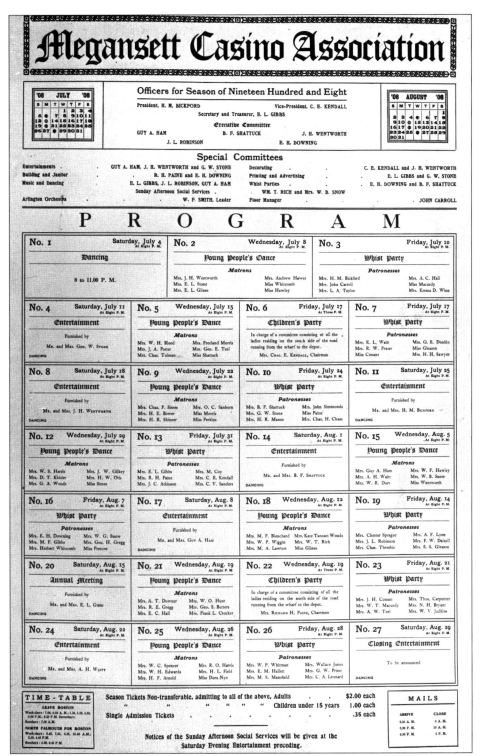

The 1908 summer program for the Megansett Casino featured young people's dances, whist parties, children's parties, and entertainments on Wednesdays, Fridays, and Saturdays.

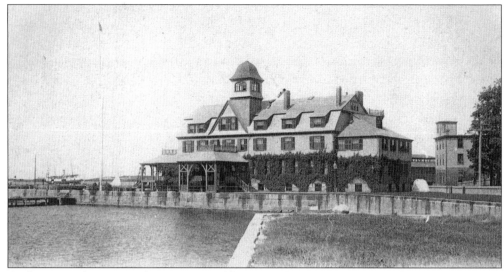

Zoologist Stephen F. Baird was appointed by Pres. Ulysses S. Grant to lead the newly created U.S. Commission of Fish and Fisheries (now the National Marine Fisheries Service). The commission's purpose was investigation of the causes of the dwindling fish stock. Baird chose Woods Hole for a laboratory, and the building (above) opened in 1885 on the corner of Water and Albatross Streets. Severely damaged by hurricanes, it was razed in 1960.

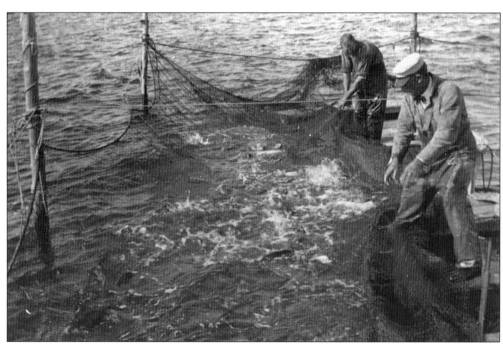

Commercial fishing grew in importance during the early 1900s. Men began to install engines in their vessels and use nets to trawl for fish. The presence of the railroad allowed fish (which was iced, not salted) to be quickly sent to markets in Boston, New Bedford, and New York. (Courtesy of Marine Biological Laboratory Archives.)

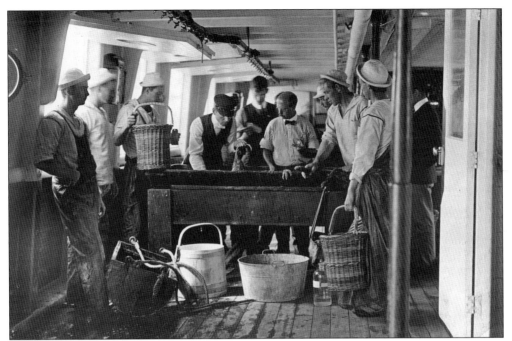

The USS *Fish Hawk* was a 156-foot-long, coal-burning steamer that served as a floating hatchery for shad, herring, striped bass, and other fish. Most of the deck space was taken up with the hatchery equipment and state-of-the-art equipment for trawling and dredging. It was the first vessel of the U.S. Commission of Fish and Fisheries, joined in 1883 by the *Albatross*, whose global explorations became famous. (Courtesy of Marine Biological Laboratory Archives.)

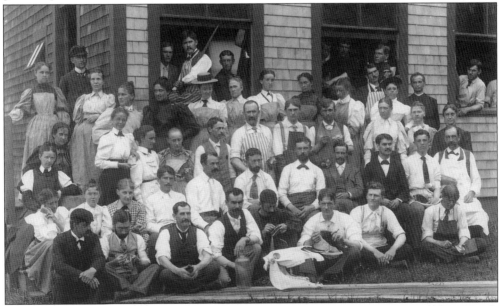

The Class of 1895 poses at the Marine Biological Laboratory, which was founded in Woods Hole in 1888. The summer laboratories were just across the street from the U.S. Commission of Fish and Fisheries. Photographer Baldwin Coolidge took pictures for each class from 1893 through 1897. (Courtesy of the Marine Biological Laboratory Archives.)

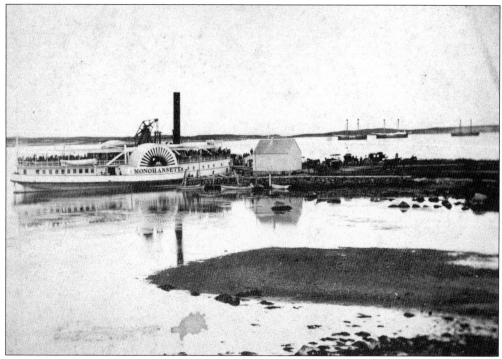

Woods Hole has been a departure point for Martha's Vineyard and Nantucket since the early 18th century. The steamer *Monohansett* served Woods Hole, the Vineyard, and New Bedford between 1863 and 1902. It carried troops and dispatches during the Civil War.

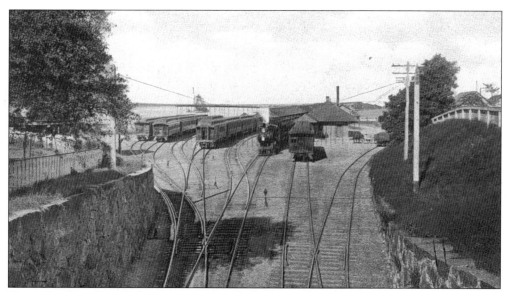

The railroad tracks ended at the steamship dock in Woods Hole, where trains could be turned around for the return trip. When train service ended on June 30, 1959, the Steamship Authority purchased the property for a parking lot and demolished the station.

Four

THE TOWN
GROWS GRACEFULLY

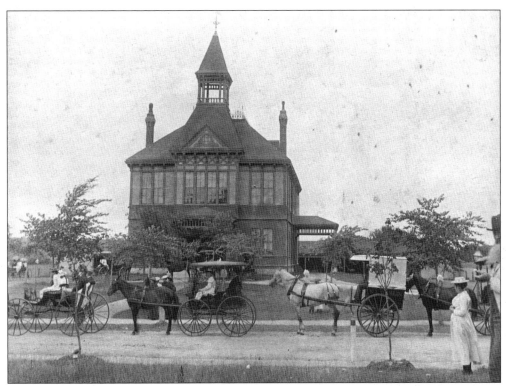

The explosion of development along Falmouth's coast in the late 19th century enriched the town and enabled it to offer new municipal services. The new town hall was built in 1880 on a design by architect Samuel Kelley of Boston and Harwich. It stood west of the present library. The second floor was the scene of town meetings, graduations, dances, plays, and concerts. Offices were located on the first floor, and the jail was behind the building. It was demolished in 1965.

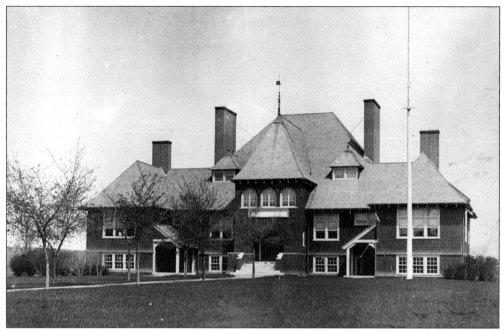

Lawrence High School, the first public high school, was built in 1895. This remarkable wooden building stood on what is now the library lawn on Main Street until 1953. The prominent Boston architectural firm of Andrews, Jacques and Rantoul designed it. One of the many school traditions was that only seniors could enter and leave by the front doors. The east wing of the library now stands on the building site.

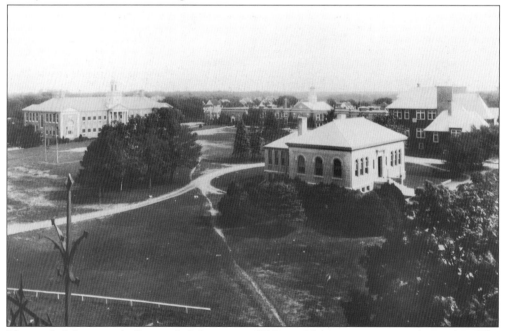

The roof of the town hall provided this view of Falmouth's growing municipal complex. The memorial library of 1901 is at the center, with the high school on the right. By the 1930s, the town had added the junior high school and a new village school behind the library.

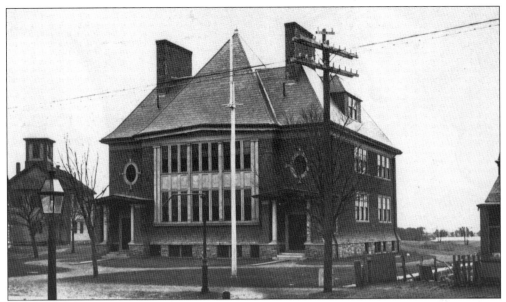

The Old Village School of 1904 stood at the opening of the present Town Hall Square. Cooper and Bailey of Boston were the architects of this highly regarded building. By 1932, the building was overcrowded, and classes were moved to a new village school. The old school became the town's community center. The Work Projects Administration gave classes during the Great Depression, and the First District Court of Barnstable held weekly sittings. The community center was demolished in 1966.

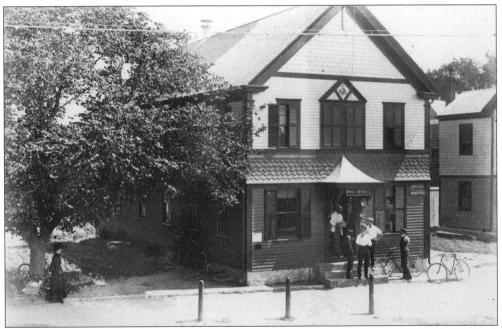

In 1902, the post office was located in the old Masonic Hall on Main Street. The original building has been obscured by subsequent renovations. The lodge was founded in 1798. Standing in front are, from left to right, Percy Reese, Albert Stedman, John Hamblin, Asa Johnson, and W.A. Stally.

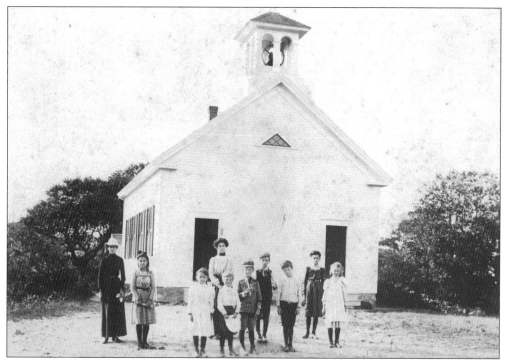

A distinct style of school architecture developed in the late 19th century. The Quissett School, pictured in 1902, is a good example. Most buildings were wooden, with a cupola such as the one shown here. The teacher is Jennie M. Cilley of Westbrook, Maine. The students are, from left to right, Edith Fish, Mary Delano Davis, Mary Joseph, ? Rankin, Harold Irving, Joe Joseph, Willie Rankin, Frances Draper, and Florence Eldred.

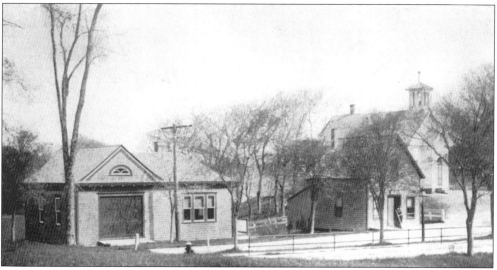

In 1900, Teaticket Village was centered around fire hose house No. 1. The volunteer fire department stored its hose wagon at this location, and the Hamlin grocery store (left) and the post office (center) were located there as well. They have been replaced by the Stop & Shop parking lot. The former Teaticket School (far right) was destroyed by fire in 1912. Another school was built in its place and is currently used by the local VFW.

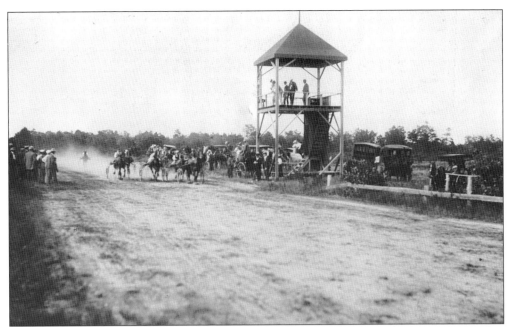

On January 18, 1896, a group calling itself the Gentlemen's Driving Club met at the town hall to discuss building a park for trotting races. They laid out a 24-acre trotting park with an oval track 200 yards in length. The track operated for six years, offering bicycle races as well. A small stand for officials was erected. In the 1990s, the town acquired the trotting park site for athletic fields.

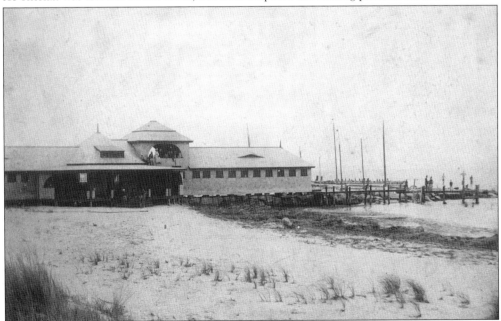

The town built this Shingle-style public beach house at the Old Stone Dock on Surf Drive. Called the Casino, the building contained bathhouses and ice-cream and umbrella-rental shops. A long wharf extended from the building into the water. Most of the Casino was destroyed in the Hurricane of 1938. The town erected a new beach house, but most of this was destroyed in the 1944 hurricane. Only the center remains in place today.

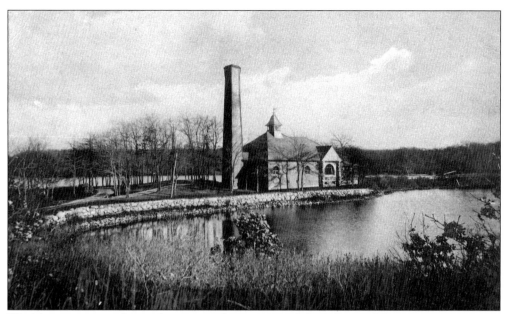

Wealthy summer residents who were seeking improved firefighting ability to meet insurance requirements developed Falmouth's water supply system in 1898. Before this, town water had come from drilled, hand-pumped public wells. The waterworks and pumping station at Long Pond were designed by Ernest N. Boyden in the Queen Anne style. The town took over the system in 1902. The pumping station is on the National Register of Historic Places.

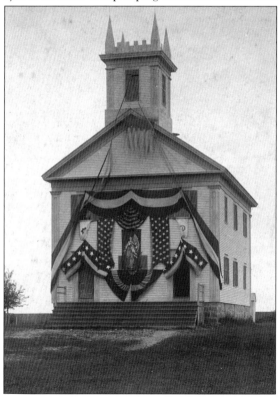

All Falmouth turned out to celebrate its 200th anniversary celebration in 1886. The old grammar school was decorated with bunting for the occasion. The building is now the Odd Fellows Hall on Town Hall Square. It originally stood closer to Main Street. When moved to its present location in 1906, the building was turned 180 degrees, a portico was added, and the steeple was removed.

In 1886, the town celebrated its bicentennial on the grounds off what is now Walker Street. Below, a line of carriages heads to the bicentennial tent in the distance.

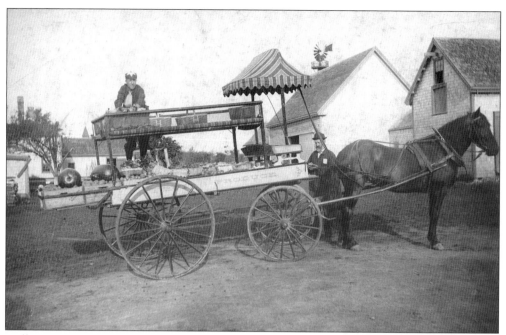

William Holmes sold vegetables door-to-door during the 1890s. Below, owner Mrs. Lewis Weeks is in her store in 1892, at work trimming hats.

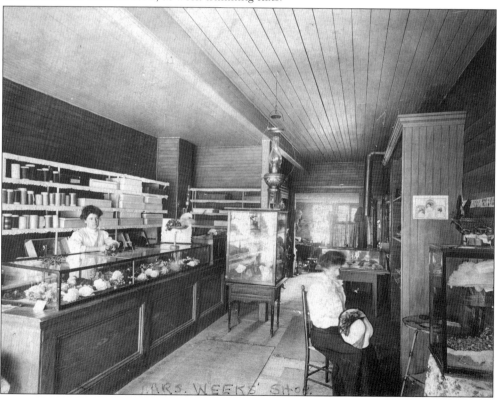

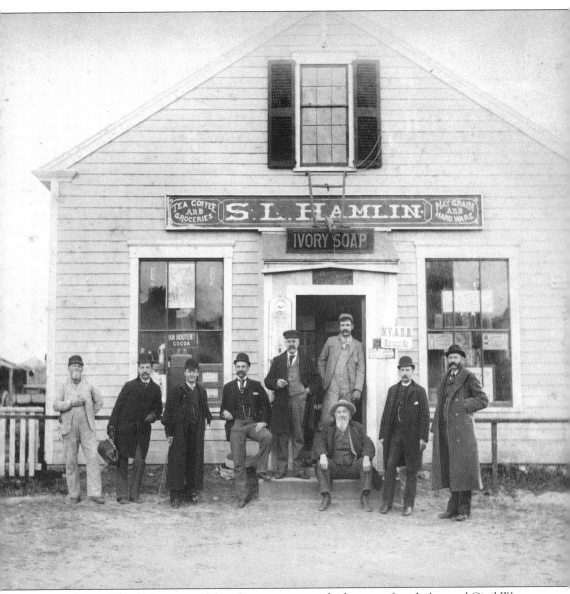

Capt. Solomon Hamlin's store on Main Street was a popular hangout for whalers and Civil War veterans. Hamlin, a retired whaler himself, sold a variety of goods, including railroad tickets, Ivory soap, tea, coffee, Van Houten cocoa, and molasses. His store stood opposite Hamlin Avenue and is still attached to the back of one of the present stores.

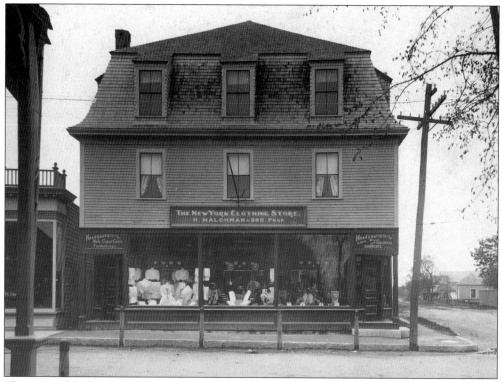

The original Malchman's building on the corner of Main and Walker Streets was typical of the town's commercial buildings *c.* 1900. It was remodeled in the 1930s and is now brick. Malchman's closed in 1984, and the Puritan Clothing Store leased the building.

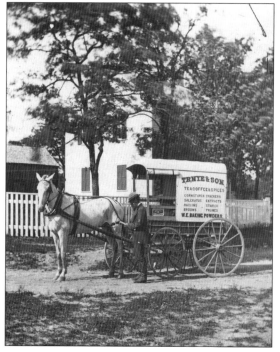

T.R. Nye's sign proclaims that he sells tea, coffee, spices, cornstarch, saleratus, raisins, brooms, crackers, extracts, starch, prunes, and baking powder.

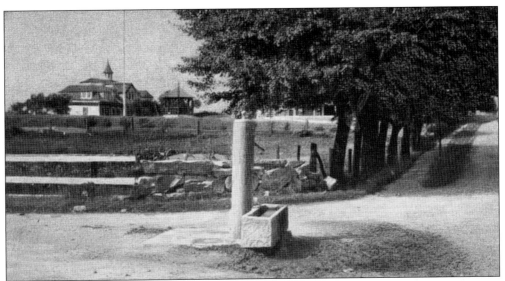

Every village had a public pump, and this one in North Falmouth has been preserved by the village. In the background is the carriage house built by William Spencer in 1904. It had been used as a nightclub called the Banjo Room in the 1960s. The house that once stood in front of the barn was a summer restaurant in the 1950s. The house has been demolished.

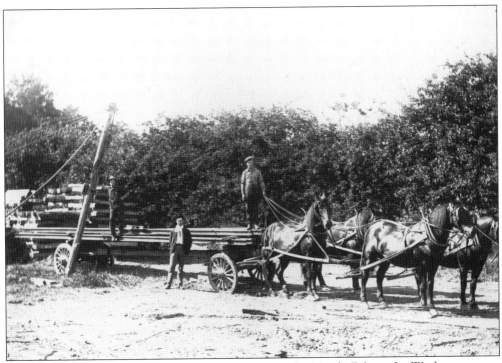

These men have been working on a street railway for North Falmouth. Work was never finished, however, and the streetcars never reached Falmouth.

While sections of Falmouth along the shore developed rapidly, some of the rural villages remained untouched by summer tourism. This scene shows Teaticket *c.* 1890. Fire Hose No. 1 is the building in the foreground; it stood east of the entrance to what is now the Stop and Shop. The post office is next to it. The cupola that rises above is part of the Teaticket School.

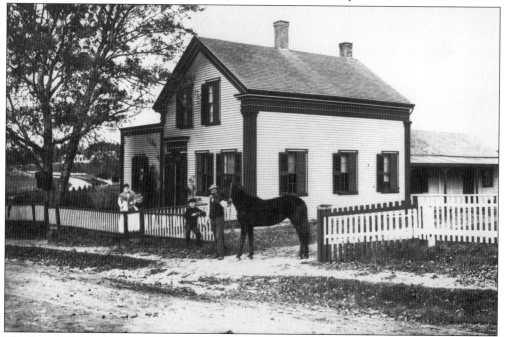

The Francis Baker house, at 34 East Falmouth Highway, was built in 1855. It still stands near the corner of Oxbow Road. Baker, a master mariner, built it in the late–Greek Revival style, with its gable end to the street. He also operated a store and stagecoach stop in the building. (Courtesy of Douglas Correllus.)

The Waquoit stage made regular daily runs to Falmouth. In this photograph, it is about to start for Falmouth on April 20, 1907. (Courtesy of Margaret Briana.)

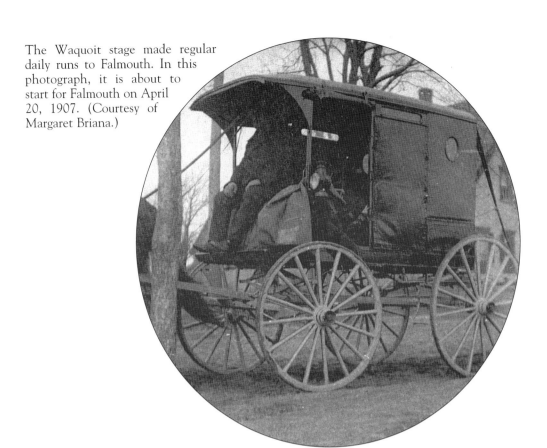

Riverside Cottage, on Martin Road, was the summer home of Abbath L. Hatch. This 1886 photograph is typical of the period when family members dressed in their finest and stood outside to be photographed. The house overlooked the Moonakis River. (Courtesy of Margaret Briana.)

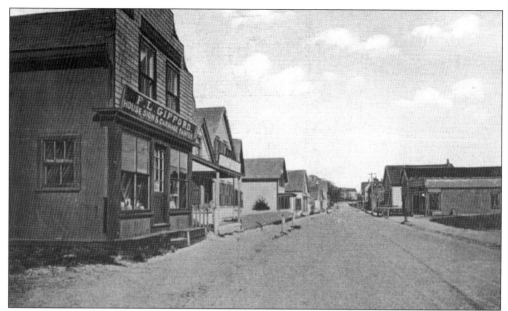

This *c.* 1900 postcard of Water Street in Woods Hole shows F.L. Gifford's House, Sign and Carriage Paint Shop on the left.

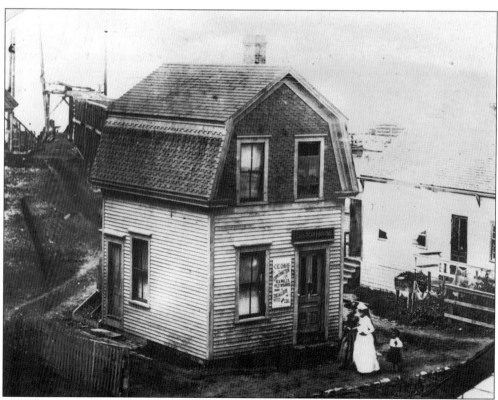

In 1880, the old customs house also served as the office of C.E. Davis, a dealer in wood and coal. Woods Hole was part of Barnstable's customs district from 1789 to 1913.

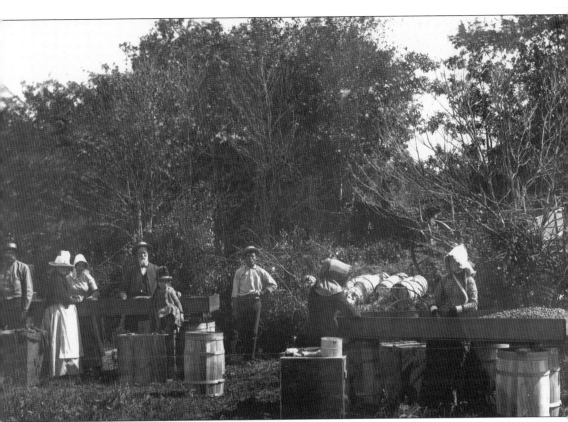

Photographer Fred Small captured this local group harvesting berries in West Falmouth. In the 1880s, cranberry growing became a business that brought many Portuguese immigrants to town for the harvest.

The family of whaling captain Samuel F. Davis traveled with him on his four-year cruises until they were of school age. Davis, captain of the *Desdemona*, was accompanied by his wife, Salome. Three of their children were born on the island of St. Helena. Wives of whaling captains frequently accompanied their husbands after 1850, when voyages lengthened to three and four years. (Courtesy of Mystic Seaport.)

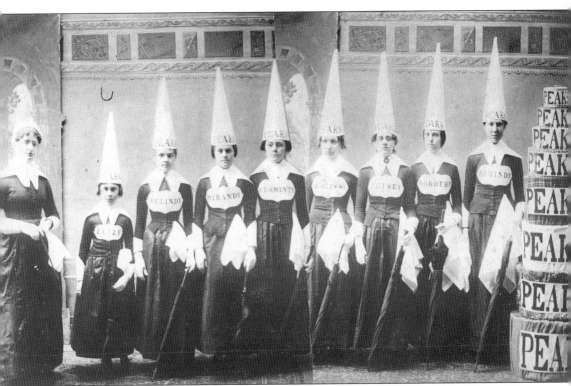

Who (or what) were Peaks? The back of this photograph reads, "Entertainers, singly and in chorus, drilled by Mrs. Julia Wood, who lived in one of the Falmouth Historical Society houses." The entertainers are, from left to right, ? Loud, Nett Stentiford, Lottie Edwards, Maud Stentiford, Love Hewins, Nellie Hamilton, Bessie Davis, Susie Emily Herendeen, and Susie Warren.

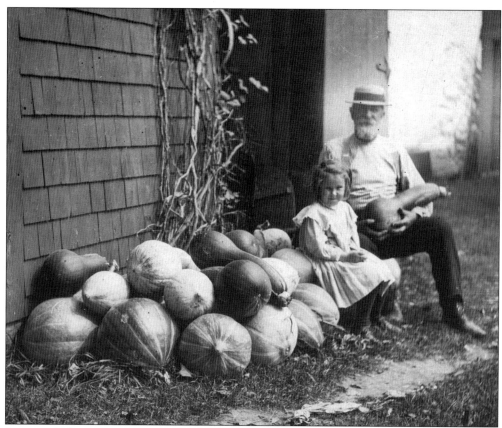

Despite all the new construction, Falmouth remained a rural town at heart.

Fred N. Bowman's home on West Falmouth Highway was one of a number of small half-Cape farmhouses along the road's edge.

Five

THE AUTOMOBILE ARRIVES

The automobile made it even easier for visitors to reach Falmouth. The town's popularity as a summer resort continued to grow as cars replaced horse-drawn carriages on Main Street.

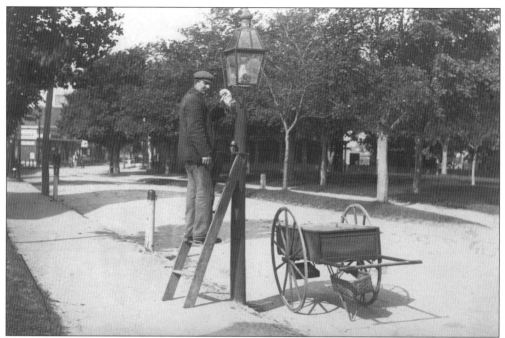

Charles Nichols was the town lamplighter. In 1907, he earned $399.96 for lighting Falmouth village's 80 streetlights. He is working on the light in front of what is now the Elm Arch Inn. The old town hall is across the street. By 1910, the village streetlights were electrified.

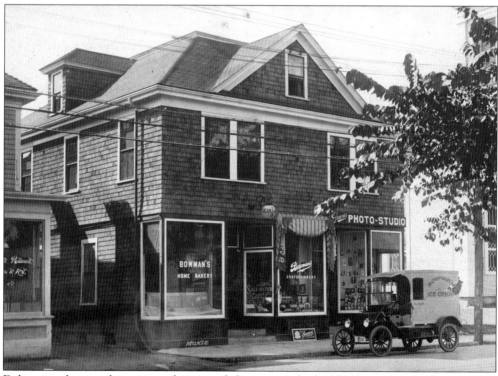

Deliveries of materials were soon being made by motor vehicles like Bowman's Ice Cream truck.

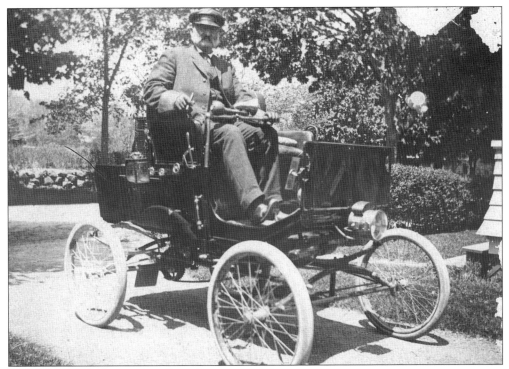

Dr. J.T. Walker poses at the tiller of his automobile.

Mrs. Edward N. Fenno and her sons Edward and Bradlee Fenno pose outside their Shingle-style home, which is now a part of the Quissett campus of the Woods Hole Oceanographic Institution. The house was built in 1902 as part of the 190-acre estate of Boston wool broker Edward Fenno.

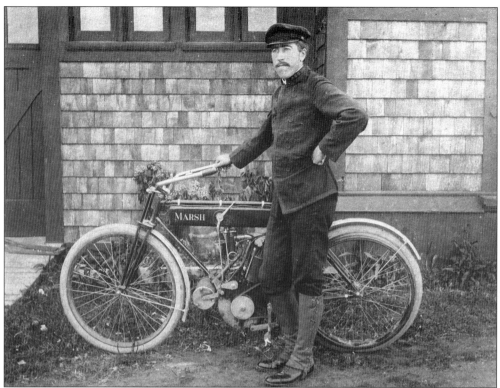

George Gilbert Swain is pictured with his motorcycle at Penzance Point in 1905. Swain worked for George B. Wilbur as chauffeur and on his yacht.

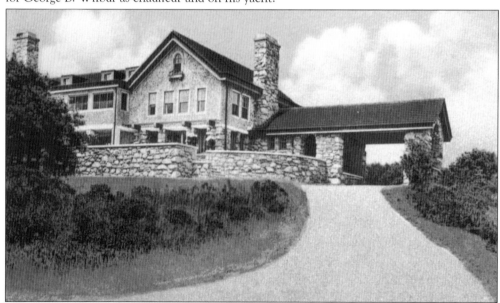

Gladheim was the residence of Dr. J.P. Warbasse at the tip of the exclusive Penzance Point development in Woods Hole. Warbasse, the founder of the Cooperative League of the U.S.A., hosted Sunday meetings on his estate to which spokesmen for many anti-establishment causes were invited.

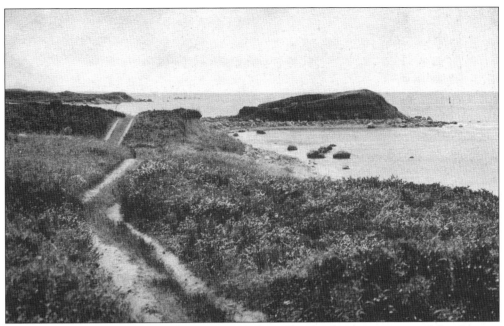

The Knob marks the entrance to Quissett Harbor. This land was once part of the Quissett Harbor House but is now protected by the Salt Pond Areas Bird Sanctuaries.

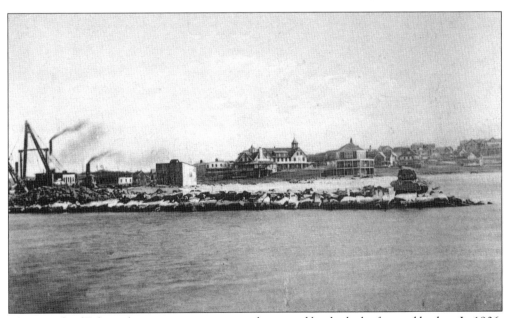

The growth of Falmouth as a summer resort was hampered by the lack of a good harbor. In 1906, the town hired Gen. George W. Goethals, who later built the Panama Canal, to turn Deacon's Pond into a harbor. A thin strip of land separated the pond from Vineyard Sound. On September 10, 1908, Alonzo Wells of Falmouth Heights and Worcester sailed the first boat into the new harbor.

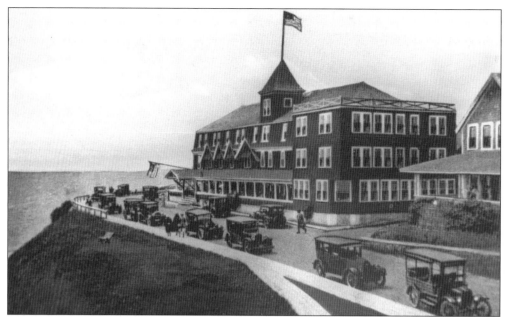

The Terrace Gables was the Grande Dame of Falmouth hotels in the era when vacations at summer hotels were fashionable, recalled Arnold Dyer in *Hotels and Inns of Falmouth*. Established in 1892, the hotel operated through the early 1960s. Its reputation declined as it became the Brothers 4 and then Yesterday's, catering to the younger set. Demolished in 1988, it was replaced by the Terrace Gables Condominiums.

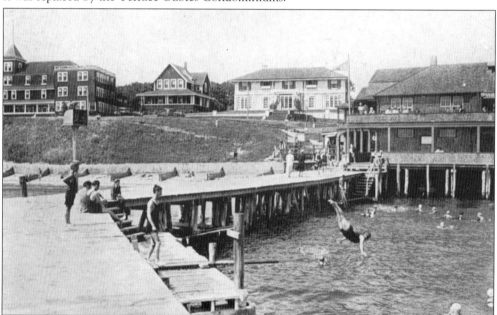

From the porch of the Terrace Gables, one had a fine view of the ocean and activities at the Casino across the street. The Casino, earlier known as the Cottage Club, was the heart of Falmouth Heights. Its pier was the center of water activities because there was very little beach. Alongside the Cottage Club were tennis courts. The baseball field was across the street. (Courtesy of Kevin Smith.)

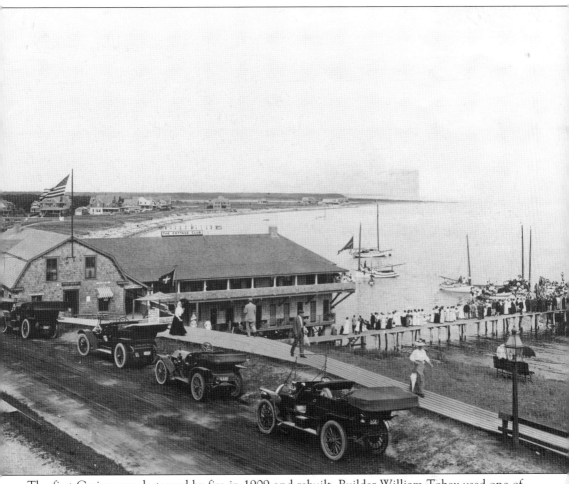

The first Casino was destroyed by fire in 1909 and rebuilt. Builder William Tobey used one of his favorite designs, the Dutch Colonial gambrel, in the second building. The building contained the village post office and a movie theater. The gambrel roof became a popular style in Falmouth Heights. With its conversion to a nightclub and restaurant, the Casino became a popular place for college students in the 1960s and acquired a poor reputation with its older neighbors. It did not reopen for the summer in 2000. Plans to replace the Casino with a restaurant and condominiums are pending. (Courtesy of SPNEA.)

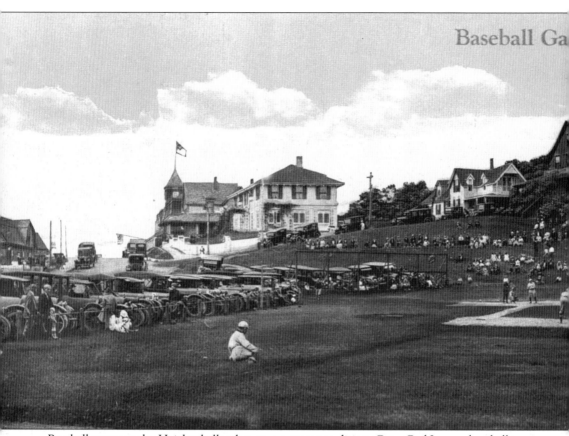

Baseball games at the Heights ballpark were a summer tradition. Cape Cod League baseball teams played here from 1923 to 1939 and from 1946 to 1964. Several players went on to play in the Major League. Games were well attended. The gently sloping hill around the field formed a natural

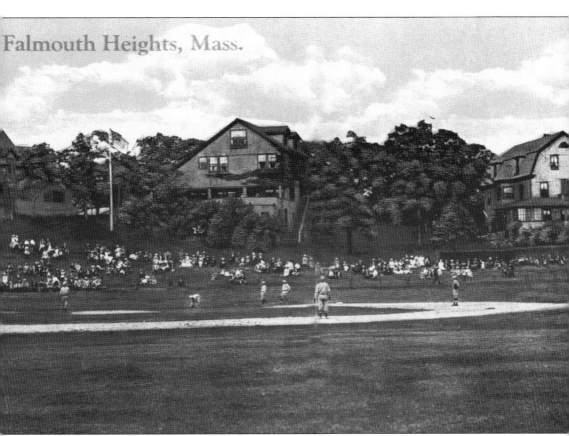

Falmouth Heights, Mass.

amphitheater where spectators sat. The crowd passed a hat to collect money for the players; there was no admission charge. In 1964, the league moved to Fuller Field to play under the lights. The Heights ballpark remains a site of more informal games. (Courtesy of Marjorie Ballard.)

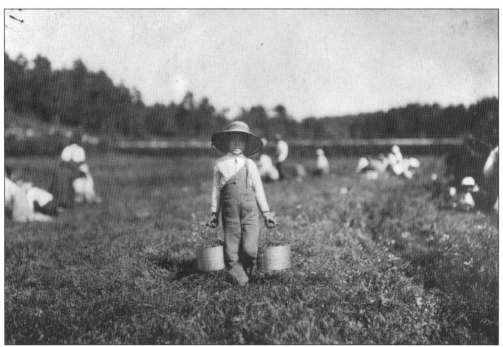

New York City schoolteacher Lewis Hine became an investigative photographer for the National Child Labor Committee in the early 20th century. As part of the committee's efforts to abolish child labor, Hine photographed children working in factories, mills, mines, meatpacking houses, and farms. On a visit to Falmouth in 1911, he found children working in the cranberry bogs. Above is Belford Coldas, an eight-year-old from New Bedford, on Week's Bog near Waquoit. Below, pickers on Swift's Bog include Joe Perry, 10 years old. (Courtesy of Spinner Publications.)

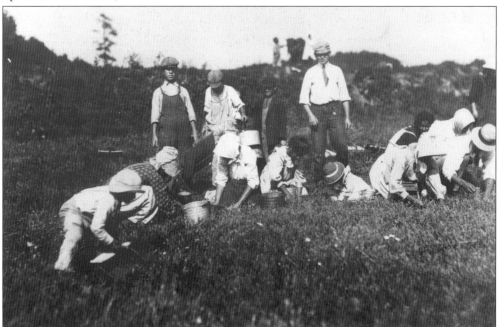

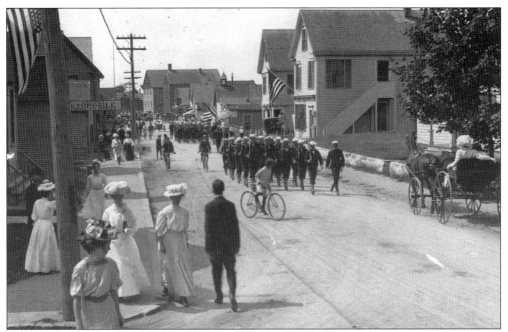

Sailors parade up Water Street in Woods Hole at the end of World War I.

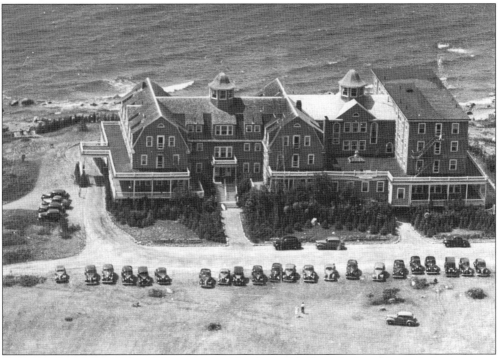

Construction of the landmark Sippewissett Hotel on a bluff overlooking Buzzards Bay began in 1899. The hotel underwent a number of name changes and bankrupted more than one owner. John R. Peterson took over in 1939 and ran it successfully as the Cape Codder until 1976. The hotel was sold in 1988, demolished, and replaced by condominiums. The loss of the Cape Codder spurred interest in historic preservation in Falmouth.

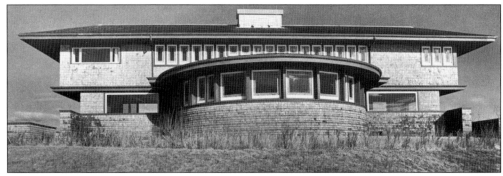

Another coastal landmark is the Airplane House in Woods Hole, which was built in 1912 by Charles Crane for his daughter Josephine and her husband, Harold Bradley. The architects, Purcell and Elmslie, had been proteges of Chicago architect Louis Sullivan. (Courtesy of the Falmouth Enterprise.)

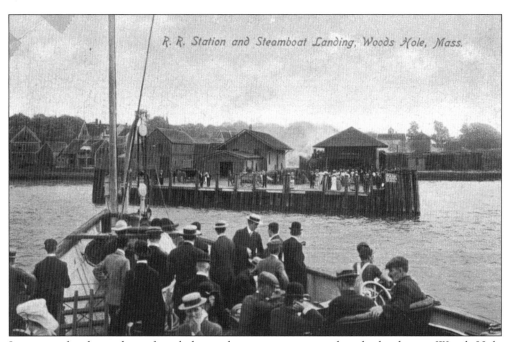

In a scene familiar today, a ferry laden with passengers approaches the landing in Woods Hole after visiting Martha's Vineyard. Instead of going to cars or buses, they would depart via the train.

Six

STRAWBERRIES AND SCIENCE

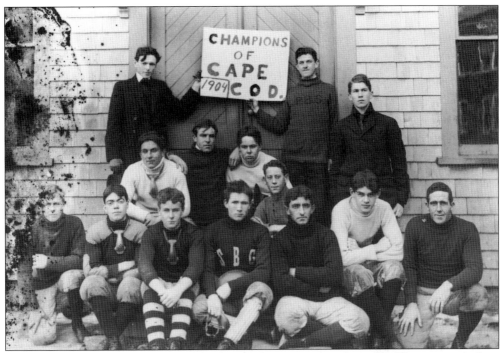

Falmouth football champions of 1904 ended their season with pride. The team members identified here are John J. Scannell, ? Crowell, Ernest A. Powers, John Murray, Frank Murray, Charles Newton, John Barry, Freeman B. Hall, James A. Smalley, Charles A. Davis, Edgar E. Burgess, William Grew, Summer E. Burgess, and John Wheeler.

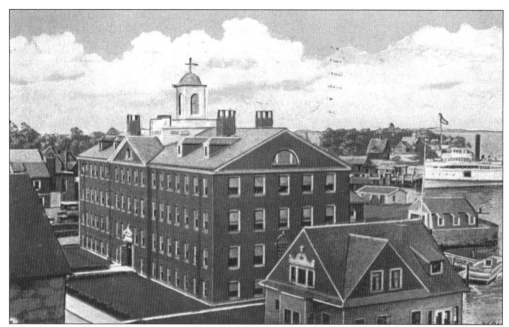

The Woods Hole Oceanographic Institution (WHOI) opened its headquarters in the Bigelow building in 1930 with the support of the Rockefeller Foundation and the National Academy of Sciences. Research funds dried up in the Great Depression, however, and WHOI remained a summer institution until World War II, when its research capabilities drew heavy government support. WHOI is now the largest employer in Falmouth.

The first Eel Pond drawbridge in Woods Hole was built in 1914 to replace the stone bridge of 1878. The present drawbridge was built after the Hurricane of 1938 destroyed the first. The bridge allows boats to pass between Eel Pond and Great Harbor. (Courtesy of the Falmouth Enterprise.)

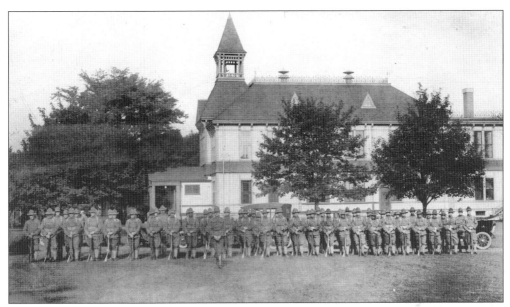

Ninety-five men signed up in April 1917 to serve in the Home Guard during World War I. The town raised $5,000 to equip them. In June of that year, 268 men between 21 and 30 had registered for the draft. By the end of the war, 216 had served in the armed forces. Five were dead.

A World War I veteran exchanges greetings with one of the last surviving Civil War veterans, both unidentified.

The Falmouth Mushroom Cellars—built on Gifford Street in 1911 and financed by wealthy summer residents John Dwight, Louis Whiting, and Robert Morse—were to be the largest growing and canning operation in the world. The plant closed after five years due to a mushroom blight. The Cape Cod Conserve Company took over the plant and employed more than 100 local women preparing vegetables for canning. The plant closed in 1921.

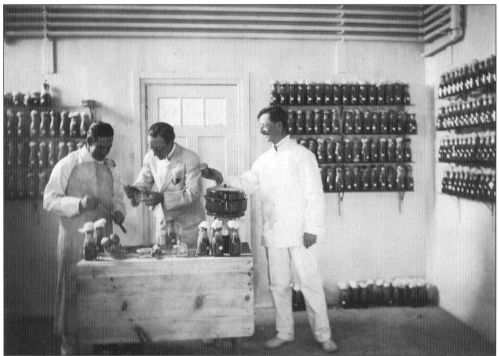

Top scientists worked to ensure quality at the Falmouth Mushroom Cellars. They included Dr. George T. Moore, a summer resident of Woods Hole who was the managing director of the Shaw Botanical Gardens in St. Louis, and A.V. Jackson of Chicago, the best-known mushroom grower in the country.

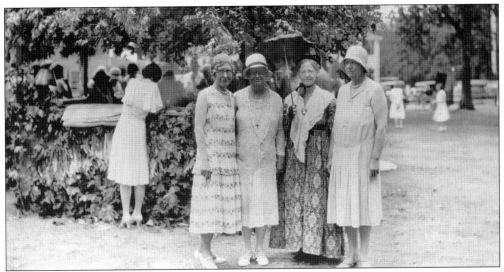

The Nursing Fete was *the* community social event of the summer from 1921 to 1979. Residents of all Falmouth's widespread villages donned their best dress and hats for music, Punch and Judy puppet shows, games, lemonade, and tea. Proceeds from the fair helped to support the Falmouth Nursing Association. Pictured from left to right are Mrs. Hubbard, Mrs. Paul Peters, Mrs. Edward Gifford, and Mrs. Sidney Lawrence.

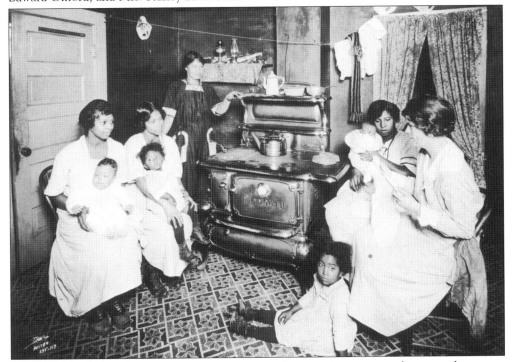

The Falmouth Nursing Association was established in 1916 to prevent disease and improve community health through prenatal care, home visits, and hygiene education. Services were open to all. A nominal fee (50¢) was asked of those who could afford it. The first nurse, Elizabeth Eliot-Smith, made her rounds on a borrowed bicycle. She lived with one board member and took her meals with another. The Fenno family often drove her on calls.

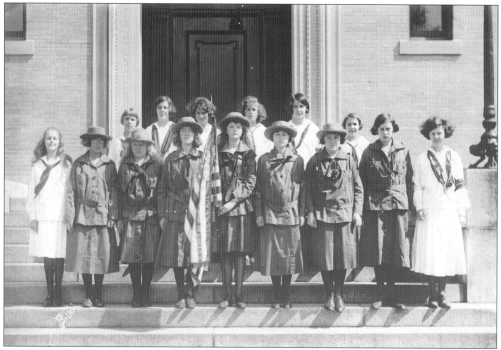

For many years, Girl Scouts troops met in the library.

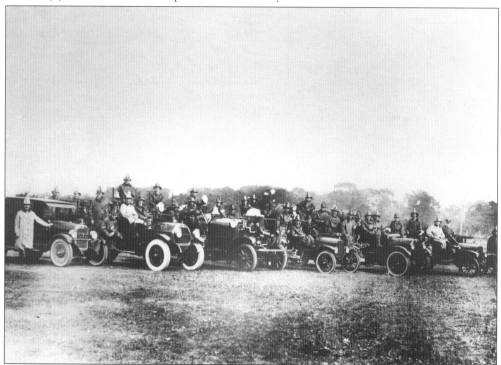

In 1897, Falmouth's fire department purchased its first engine. By the time this photograph was taken, the department's usefulness in saving property and lives had been recognized and the department had grown tremendously.

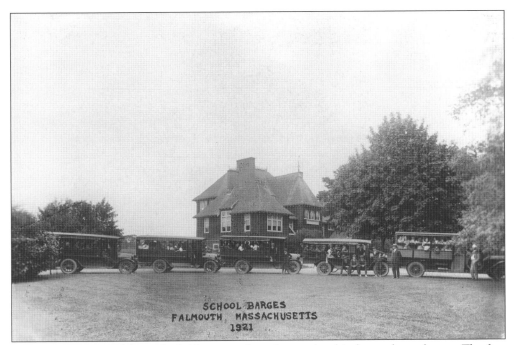

Before buses were widely used, children were brought to school in horse-drawn barges. The first motorized barges were converted trucks with seats running lengthwise. School officials recognized that providing transportation to school increased attendance. (Courtesy of Falmouth Public Schools.)

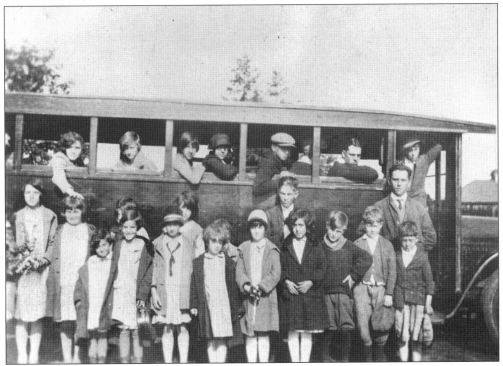

Teaticket schoolchildren go off on a field trip on an early school bus.

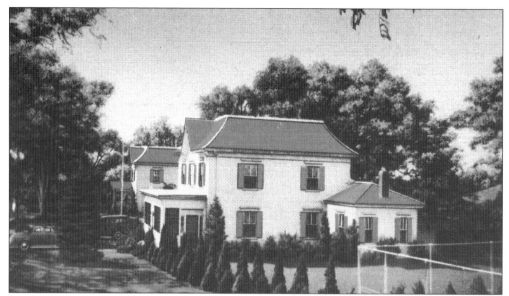

Pictured in the 1920s, the Antlers Inn in East Falmouth has had several other names. It became the Piper Inn and Tanya's Restaurant before it was destroyed by fire. The house to the left is the Oysters Too restaurant, formerly the Big Fisherman. The two similar houses were built in the 1860s for the brothers John and Joshua Robinson. Joshua was a county commissioner; John drove a grocery wagon through town.

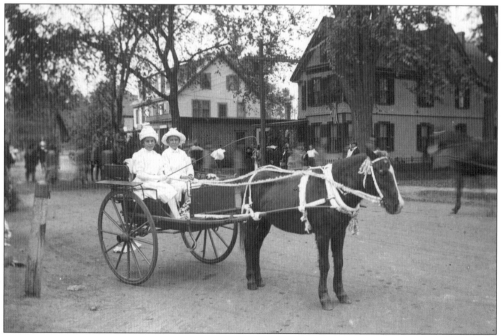

In this 1921 view, two girls in a pony cart parade down a Main Street that no longer exists. A few years later, most of the old buildings had been moved or demolished to make way for new ones. The Arza Weeks house (right) stood where the Village Cafe is today. The next building was moved back for the Weeks Block. Converted to apartments known as the League of Nations, the building was demolished in the 1993.

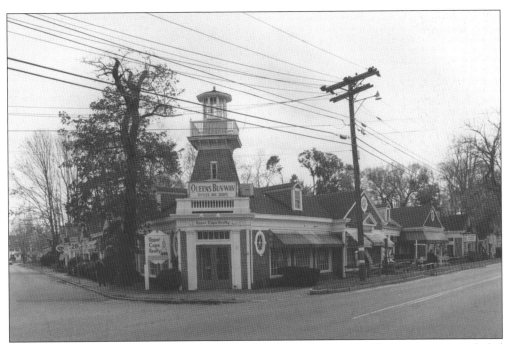

The Queen's Buyway was built in 1925 as a summer shopping center. Early occupants included the first Filene's department store on Cape Cod. Construction of the 14-store Buyway so close to the village green caused the town to adopt its first zoning bylaw in 1926.

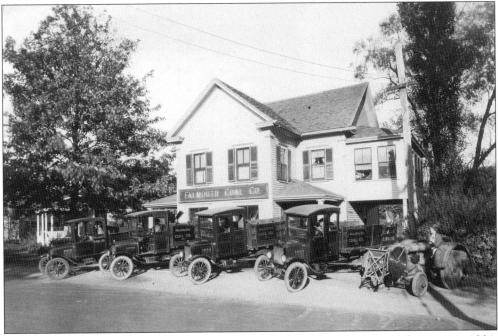

Serving as the headquarters of the Falmouth Coal Company on North Main Street since 1924, this building had been the office of a livery service run by railway station agent Wilbur Dyer and, before him, by Thomas L. Swift. The building has also been used as a paint shop and a harness shop. (Courtesy of Bill Dyer.)

St. Patrick's Church was built on Main Street in 1899 as a mission of St. Joseph's Church in Woods Hole. It remained a mission until 1931, when Rev. James A. Coyle became pastor. Since that time, the original building has been enlarged twice and now seats 850. (Courtesy of Marjorie Ballard.)

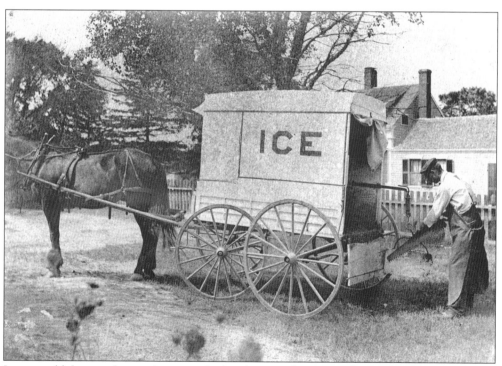

Ice was sold door-to-door and was weighed and cut on the spot to fit into kitchen iceboxes.

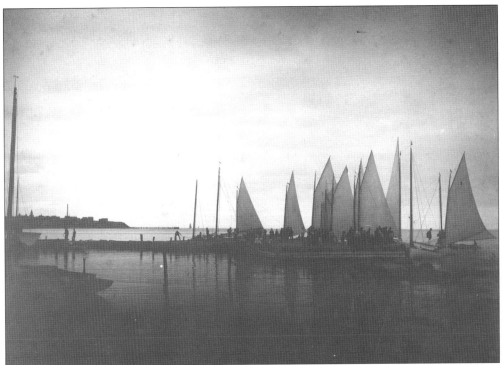

In this *c.* 1900 view, catboats reach the breakwater, which was formerly known as the Old Stone Dock. The dock had been built out into the sound in 1817 because Falmouth village did not have a natural harbor.

Old Silver Beach in North Falmouth offered bathhouses and a theater in the 1930s. The tall building in the center was built in 1929 to be the theater for the University Players Guild, a short-lived summer theater company that included among its cast members college students Henry Fonda, James Stewart, and Margaret Sullivan before they went to Hollywood.

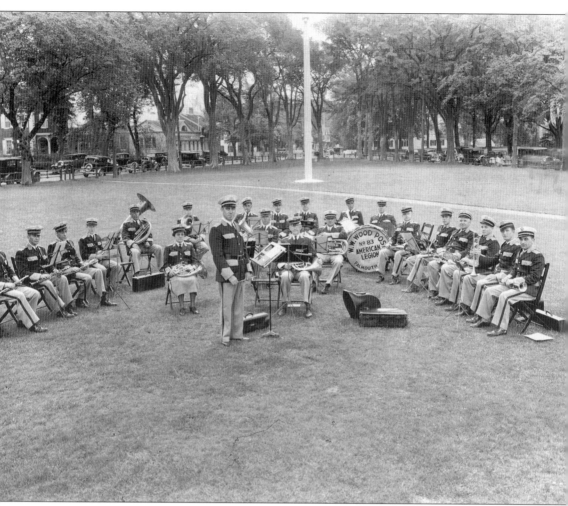

The W.W. Wood American Legion Post Band rehearses on the village green for a celebration in 1930.

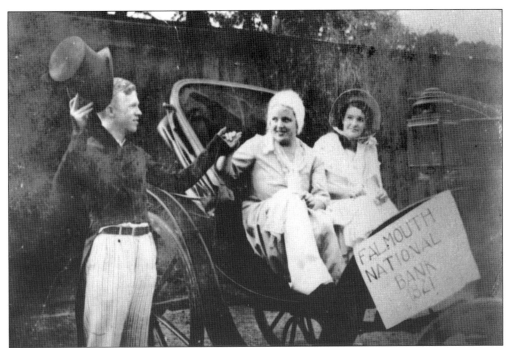

The Falmouth National Bank won a prize in a 1930s parade for entering a surrey with two horses carrying Katharine M. Barry and Eleanor Conant Yeager in costume. Arnold W. Dyer, in a top hat, drove the horses.

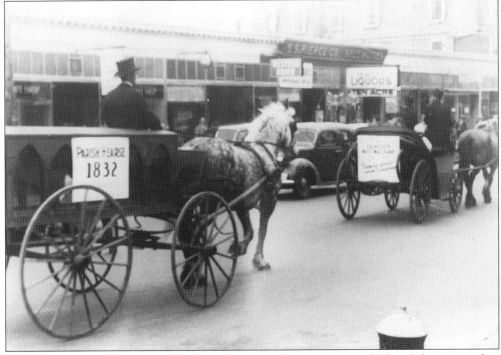

The parish hearse, attributed to the North Falmouth Congregational Church by virtue of its 1832 date, followed the Falmouth National Bank entry. (Courtesy of Margaret Briana.)

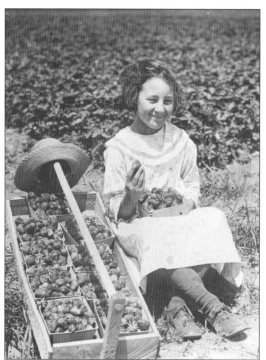

Alice Ciambelli tastes a strawberry grown on her father's farm. She grew up on one of the 500 small farms in East Falmouth and Teaticket that made the town the strawberry capitol of Massachusetts. Portuguese-speaking settlers from the Azores and Cape Verde Islands established the farms. By the 1920s, they had 600 acres under cultivation and were growing more berries per acre than any other region in the nation. (Courtesy of Alice Ciambelli.)

St. Anthony's Church in East Falmouth is called "the church that strawberries built." It was constructed in 1921 to serve the growing Portuguese community, which supported it with the profits from the third week of the strawberry harvest each year. For its first 40 years, the church was a Portuguese National Church, staffed with Portuguese-speaking priests. In the 1960s, the parish was reorganized and open to all.

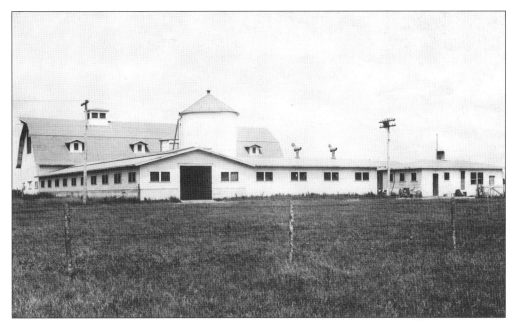

Many wealthy summer residents regarded Falmouth as a country town and themselves as gentlemen farmers. The 10,000-acre Coonamessett Ranch amassed in 1915 by Frederick Leatherbee in Hatchville, Sandwich, Mashpee, and Bourne was the largest farm east of the Mississippi. It grew acres of corn and asparagus and raised cattle, chickens, and sheep. The barn burned in 1932, but by 1925 new owners had moved into recreation, building a golf course, polo field, and inn.

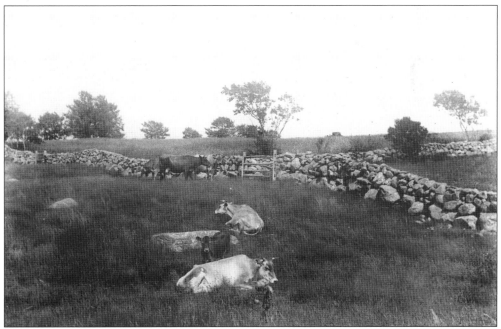

Cows were numerous in the early 20th century. Many summer residents invested in herds, and there were a number of dairies. In 1906, the town assessors listed 1,800 taxpayers and 500 cows. (Courtesy of Marine Biological Laboratories Archives.)

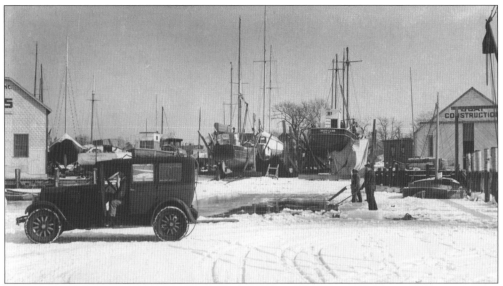

William G. MacDougall, his family, and two partners purchased Capt. W.W. Phinney's boatyard on the east side of Falmouth Harbor in 1938 and operated it as the Cape Cod Marine Service for the next 34 years. The yard fitted out Adm. Donald MacMillan's arctic schooner *Bowdoin* and restored the Kennedy family's yacht *Marlin*. Although ownership has changed, the yard is still known as MacDougall's. (Courtesy of Colin MacDougall.)

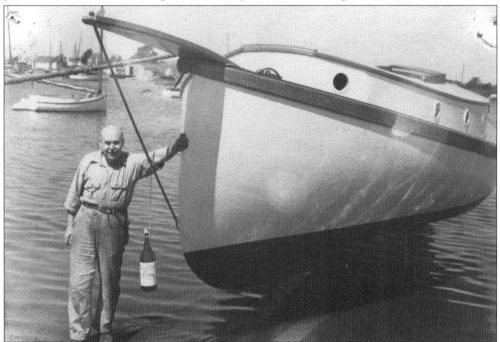

Capt. W.W. Phinney was one of the three most prominent catboat builders on Cape Cod in the 1920s. A teetotaler, he launched his last catboat, the 30-foot *Oriole*, in 1939 with a bottle of ginger ale. He sailed the boat around the sound and, with the help of his grandson, took out sailing parties. On occasion, he took groups to Cuttyhunk for a lobster feed. The Crosby and Bigelow yards were the other leading catboat builders. (Courtesy of Colin MacDougall.)

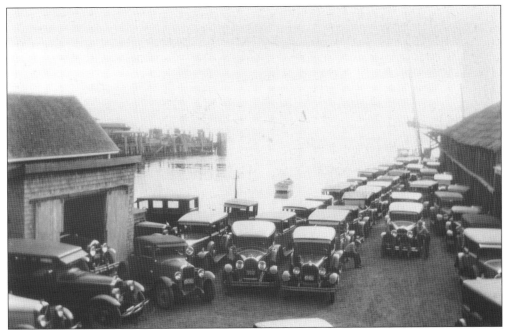

Woods Hole has had problems parking cars since the 1930s. Weekend passengers on the ferry to Martha's Vineyard parked at what was then Dyer's Dock.

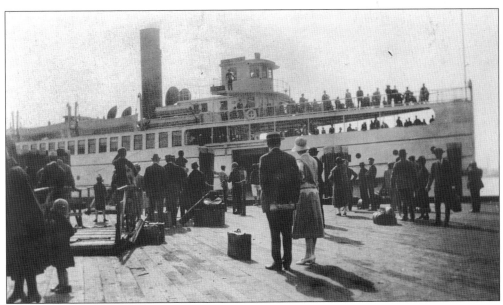

Passengers wait for the ferry to the Vineyard at the steamship dock in Woods Hole. (Courtesy of Bill Dyer.)

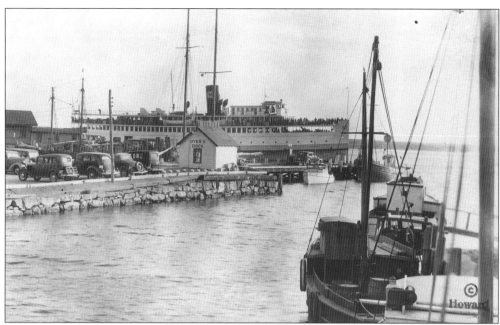

Above is a view of Dyer's Dock. Below, it has been damaged in the Hurricane of 1938. (Courtesy of Bill Dyer.)

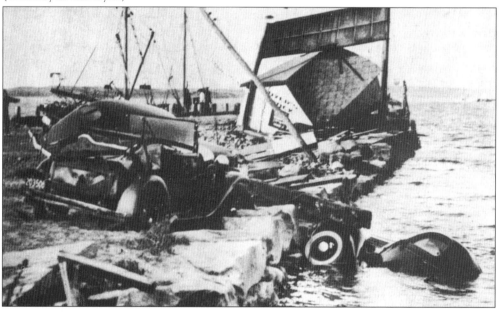

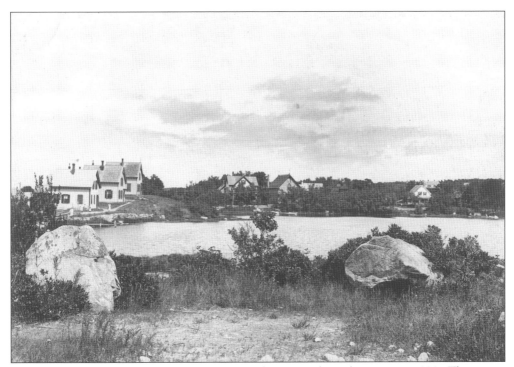

The Do Rae Me houses overlooked Eel Pond in Woods Hole prior to 1930. They were demolished to make room for the Marine Biological Laboratory's Swope Building.

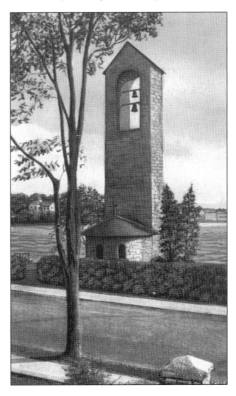

The medieval-style bell tower overlooking Eel Pond in Woods Hole was a gift of Frances Crane Lillie to St. Joseph's Church in 1929. Lillie, wife of the director of the Marine Biological Laboratory, wanted the chimes to remind the Catholic scientists across the pond of the spiritual aspects of life. The bells are named for 19th-century scientists Gregor Mendel, an early geneticist, and Louis Pasteur, the father of bacteriology.

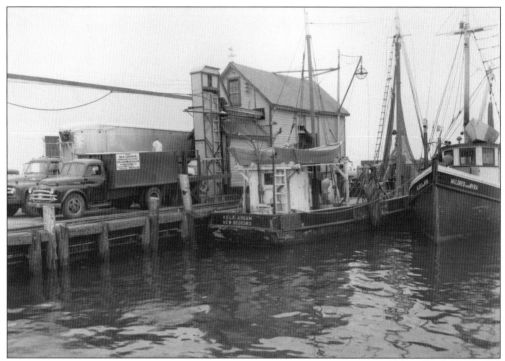

Sam Cahoon's fish market in Woods Hole was so successful that he sent fresh fish to market in Boston and New York. For a time, the market challenged New Bedford's supremacy as a fishing port but it closed in the 1960s.

An unidentified man spears eels on the Child's River in Waquoit. Some consider eel a gourmet dish. Eels can be found in streams and ponds along Falmouth's 75 miles of coastline. Two of the town's 40 ponds are called Eel Pond. (Courtesy of Margaret Briana.)

Seven

FALMOUTH GOES TO WAR

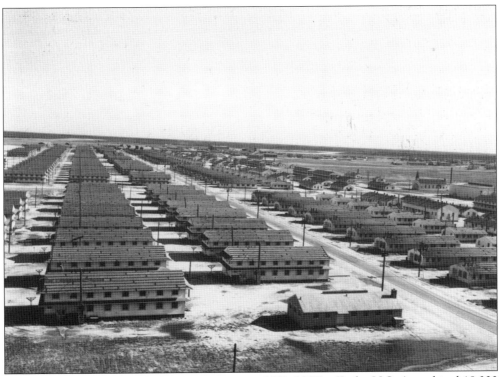

In September 1940, a year before America entered World War II, the U.S. Army hired 18,000 carpenters and laborers to build Camp Edwards, a new army training camp on the old Coonamessett Ranch in Falmouth, Bourne, Mashpee, and Sandwich. The men built 1,200 buildings in a record 75 days. The new high-paying jobs ended the Great Depression in Falmouth and put the town on a bustling year-round schedule. (Courtesy of the National Archives.)

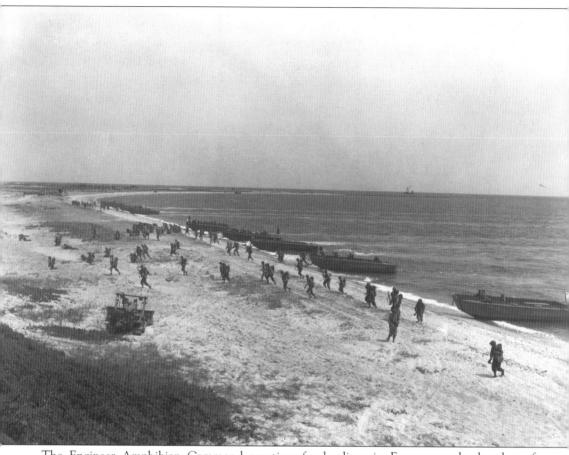

The Engineer Amphibian Command practices for landings in Europe on the beaches of Washburn's Island in Waquoit Bay. (Courtesy of the National Archives.)

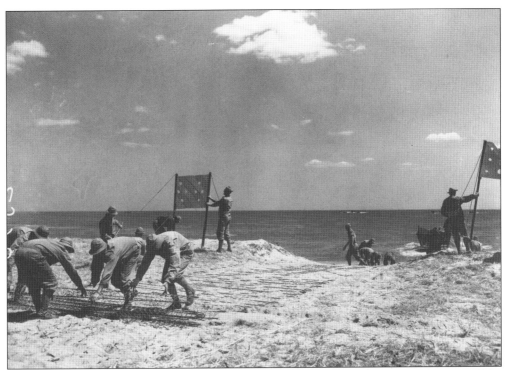

Soldiers prepare for landings on Washburn's Island by laying metal tracking. (Courtesy of the National Archives.)

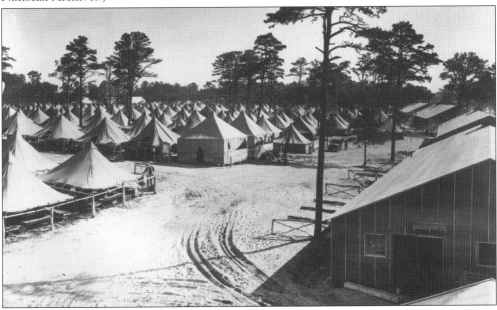

Camp Edwards was not big enough to house all the soldiers training there for World War II. Hundreds of men in the 591st Engineer Boat Regiment lived in a tent city on Seapit Road. This regiment and the Engineer Amphibian Command practiced amphibious landings on Washburn's Island in Waquoit Bay. Landing exercises were also held on Old Silver Beach and on Martha's Vineyard. (Courtesy of the National Archives.)

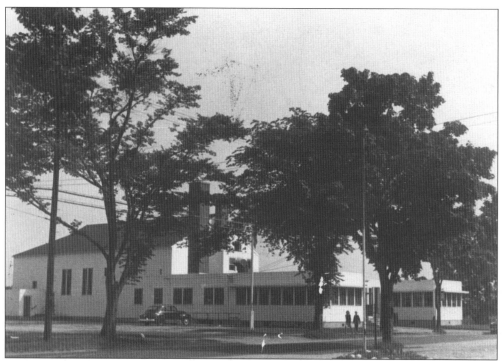

The first United Service Organizations (USOs) in the country opened on Cape Cod in 1941. Designed to serve the troops at Camp Edwards, the USOs were located in Falmouth, Mashpee, Bourne, and Hyannis. Falmouth's new USO building on Main Street became the Gus Canty Community Center after the war. (Courtesy of Isabelle Hankinson.)

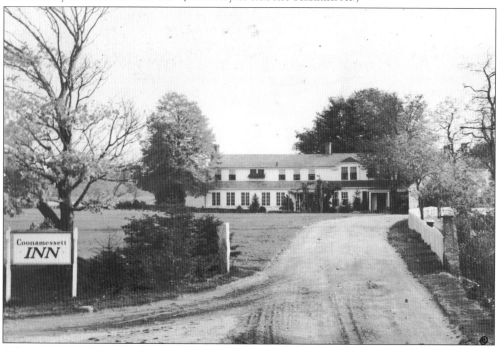

Officers often gathered at the Coonamessett Inn in Hatchville when they were off duty.

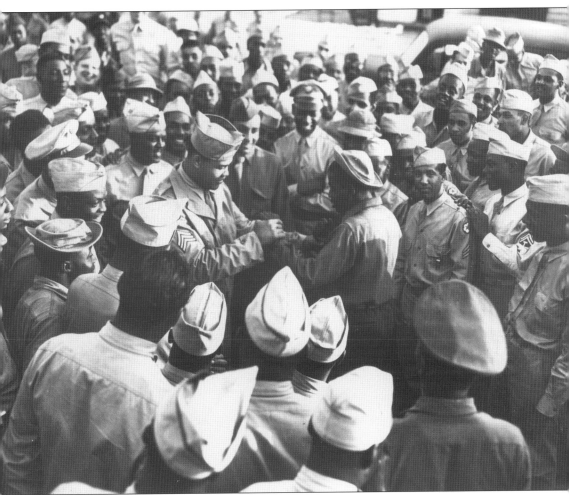

In the segregated army of World War II, Sgt. Joe Louis, heavyweight boxing champion of the world, signed his autograph for the black troops at the Mashpee USO. (Courtesy of the National Archives.)

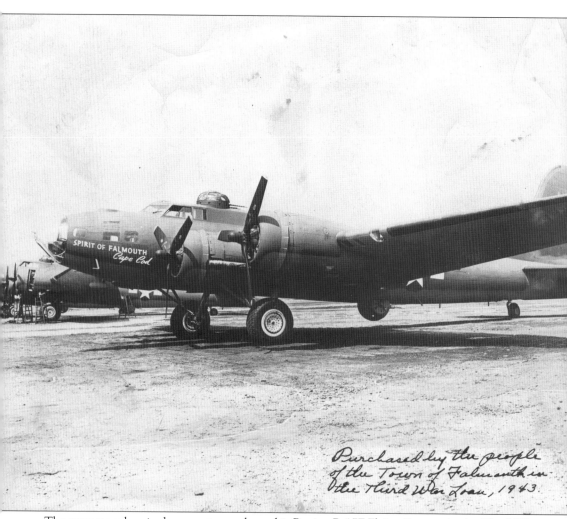

Purchased by the people of the Town of Falmouth in the Third War Loan, 1943.

The townspeople raised money to purchase this Boeing B-17F Flying Fortress in the Third War Loan in 1943. The bomber was named the "Spirit of Falmouth Cape Cod."

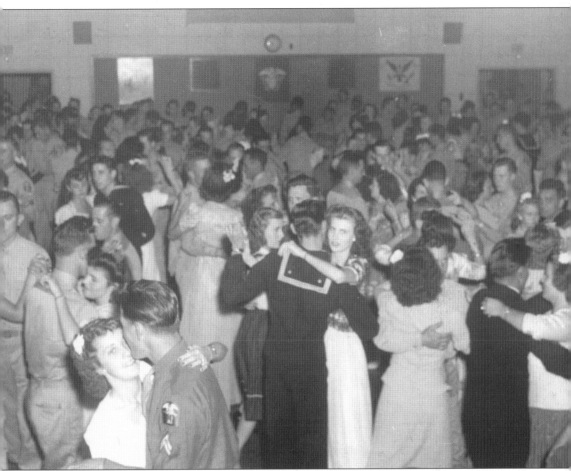

Thousands of soldiers and sailors attended chaperoned dances sponsored by the Falmouth USO. By the war's end in 1945, the USO had recorded nearly a million visits by servicemen. Isabelle Hankinson, one of the USO leaders, said the community wanted "to give the boys a home away from home. Most were so young, just out of high school. They had never been away from their own homes before. They were just like our boys, and we hoped that our boys would be welcomed wherever they were stationed." (Courtesy of Isabelle Hankinson.)

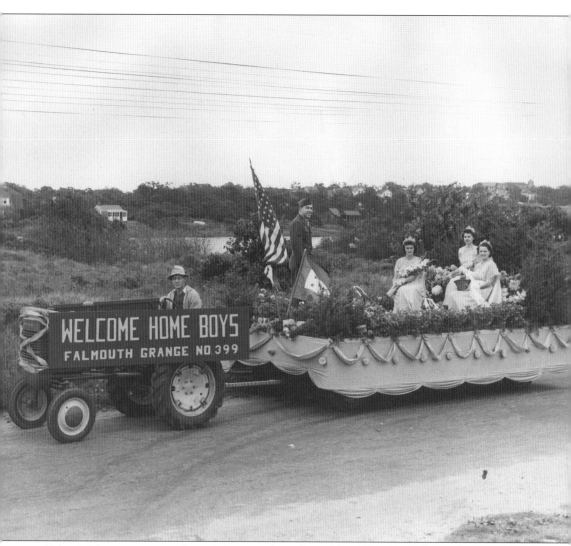

Falmouth's servicemen and women returned to a heartfelt welcome—and a town that had been permanently changed by the war. Growth has been a constant in the town since the 1940s. (Courtesy of Phil Choate.)

Eight
EMBRACING THE FUTURE

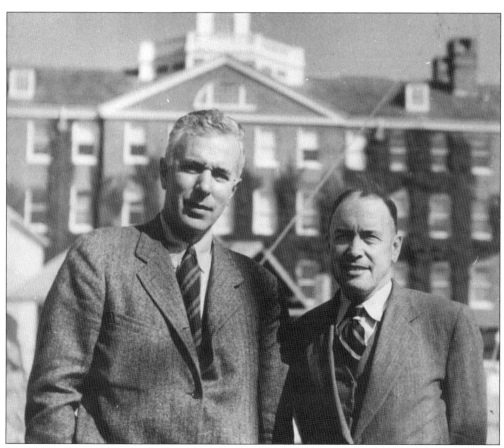

Oceanographers Columbus O'Donnell Iselin (left) and Adm. Edward Hanson Smith (right) laid the foundations in the 1940s and 1950s for the expansion of the Woods Hole Oceanographic Institution in the 1960s. Iselin was the second director of the institution during World War II, and "Iceberg" Smith was the third director. (Courtesy of the Woods Hole Oceanographic Institution.)

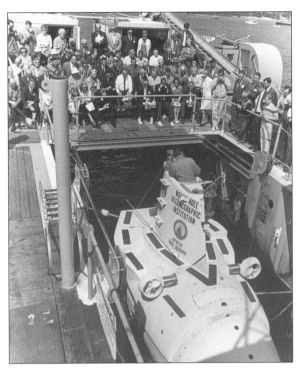

Alvin, a submersible research vessel, located a lost hydrogen bomb off the coast of Spain shortly after the Woods Hole Oceanographic Institution acquired it in 1964. The tiny submersible could hold three people. (Courtesy of the Woods Hole Oceanographic Institution.)

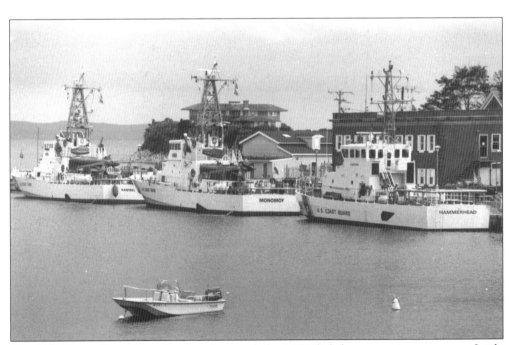

The U.S Coast Guard base developed around the 1857 lighthouse service center on Little Harbor in Woods Hole. The Coast Guard took over the Lighthouse Service in 1939. (Courtesy of the Falmouth Enterprise.)

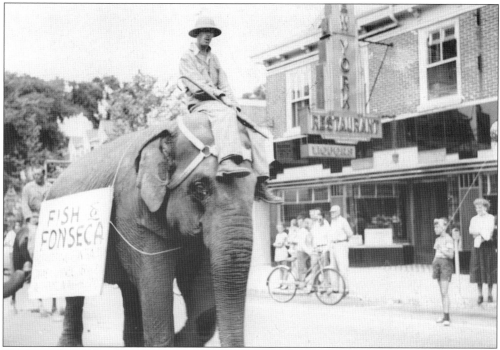

Elephants led the circus parade when the circus came to town in July 1954. As in the past, the parade made its way to the open fields off Scranton Avenue, where the big top was pitched. (Courtesy of James Cardoza.)

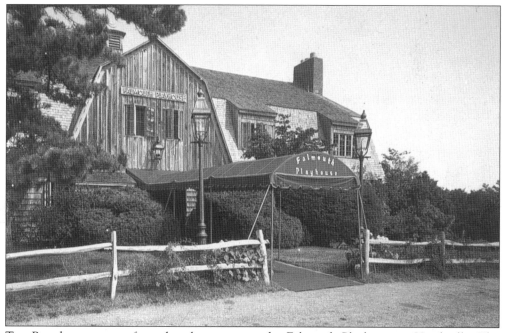

Top Broadway stars performed each summer at the Falmouth Playhouse in Hatchville. The playhouse opened in the late 1940s. The theater burned in the 1980s.

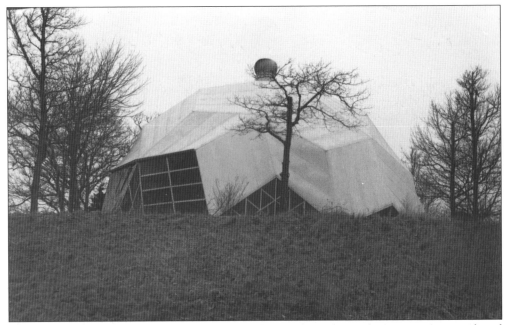

Buckminster Fuller, a visionary who thought the geodesic dome the most economical and efficient way to enclose space, designed the Dome Restaurant in Woods Hole. He built it in 1953 with his students and local architect Gunnar Peterson, who planned the restaurant. It became the largest commercially used geodesic dome in the country.

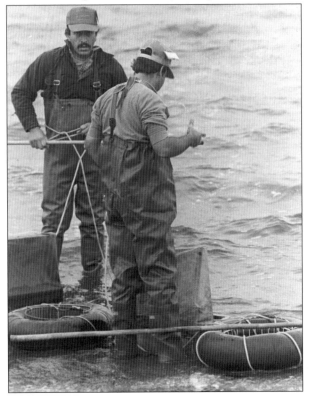

Cape scallops growing off shore are a delicious fall treat. (Courtesy of the Falmouth Enterprise.)

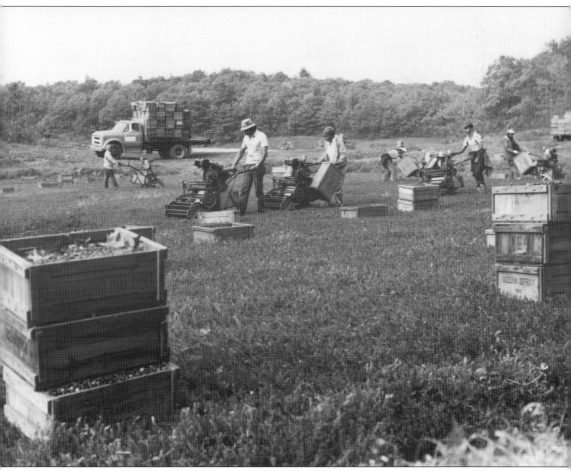

Cranberries are harvested in the fall by machines these days—no more hand picking. (Courtesy of the Falmouth Enterprise.)

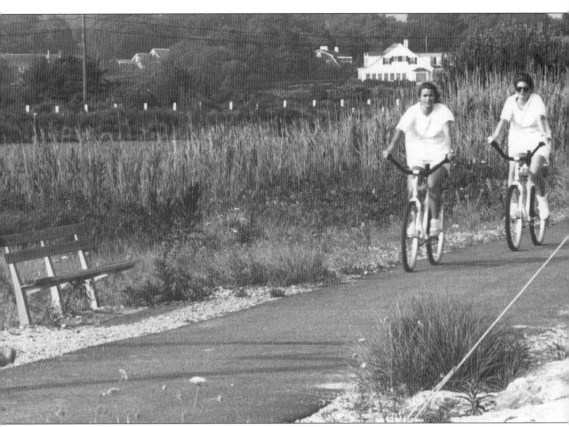

The Shining Sea Bikeway runs along Vineyard Sound on the old railroad bed from Falmouth to Woods Hole. The town created the bike path in 1975 to celebrate the national bicentennial. (Courtesy of the Falmouth Enterprise.)

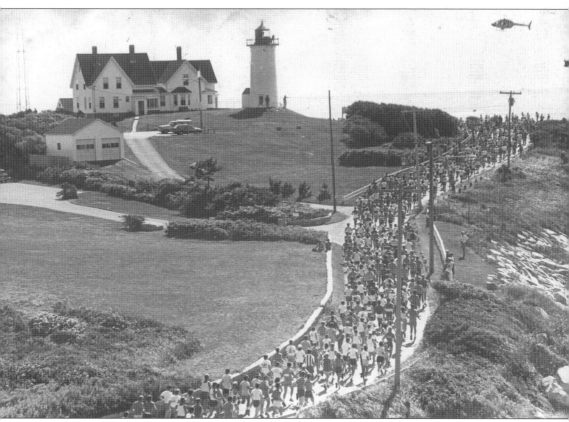

The first Falmouth Road Race, in 1973, occurred in pouring rain with 98 runners starting. By 1977, it drew more than 3,000 starters. The scenic route passes Nobska Lighthouse and ends at the Casino in Falmouth Heights. (Courtesy of the Falmouth Enterprise.)

SELECTED BIBLIOGRAPHY

Barber, John Warner. *Historical Collections: Being a General Collection of Interesting Facts, Traditions, Biographical Sketches, Anecdotes, Relating to the History and Antiquities of Every Town in Massachusetts.* Worcester, Massachusetts: Door, Howland & Company, 1839.

Dyer, Arnold W. *Hotels and Inns of Falmouth. A survey of 17th, 18th and 19th Century Accommodations.* Falmouth Historical Society, 1993.

Dyer, Arnold W. *Residential Falmouth: Homes Old and New.* Falmouth, Massachusetts: Falmouth Historical Society, 1995. Originally published by the Falmouth Board of Industry, 1897.

Falmouth-by-the-Sea: The Naples of America. Falmouth, Massachusetts: Falmouth Chamber of Commerce, 1976. Originally published by the Board of Trade and Industry, 1896.

Jenkins, Candace. *Between the Forest and the Bay.* The West Falmouth Civic Association, 1998.

Moses, George. *Ring Around the Punch Bowl: The Story of the Beebe Woods.* Taunton, Massachusetts: William S. Sullwold Publishing, 1976.

Smith, Mary Lou, ed. *The Book of Falmouth: A Tricentennial Celebration.* The Falmouth Historical Commission, 1986.

Smith, Mary Lou, ed. *Woods Hole Reflections.* The Woods Hole Historical Collection, 1993.

Spritsail, a Journal of the History of Falmouth and Vicinity. Woods Hole Historical Collection, 1987–2001.